THE MAKING OF AMERICA

INDIANAPOLIS
A CIRCLE CITY HISTORY

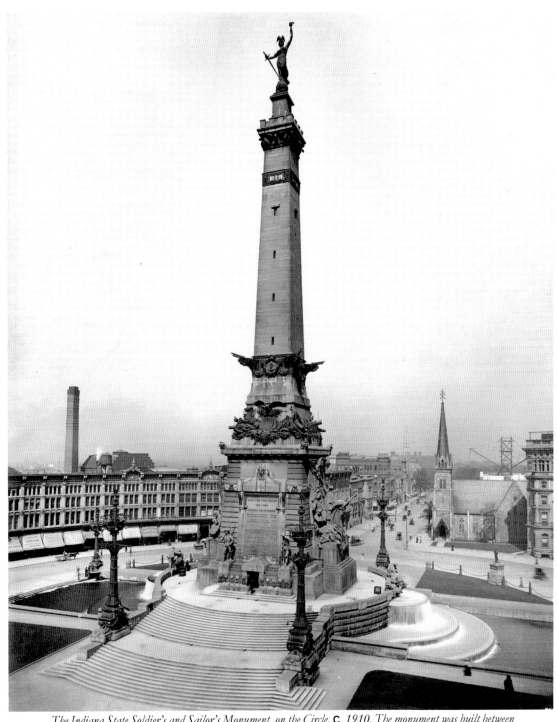

The Indiana State Soldier's and Sailor's Monument, on the Circle, C. 1910. *The monument was built between 1888 and 1901 to commemorate Indiana's Civil War soldiers and sailors. The view is looking north.*

THE MAKING OF AMERICA

INDIANAPOLIS
A CIRCLE CITY HISTORY

JEFFREY TENUTH

ARCADIA
PUBLISHING

Published by Arcadia Publishing
Charleston, South Carolina

Printed in the United States of America

Library of Congress Catalog Card Number: 2004101939

For all general information contact Arcadia Publishing at:
Telephone 843-853-2070
Fax 843-853-0044
E-Mail sales@arcadiapublishing.com
For customer service and orders:
Toll-Free 1-888-313-2665

Visit us on the Internet at www.arcadiapublishing.com

CONTENTS

ACKNOWLEDGMENTS

In a project like this that takes two years to complete, there are many people and institutions to thank. I can't possibly list everyone, so if I've left anyone out, my appreciation is no less. First I must thank my family and friends who supported this project by supporting me and my endless talk about the history of Indianapolis. Certainly they are the most tolerant of people. Secondly, I have to thank my colleagues at the Indiana State Museum and at other institutions who provided opinions and guidelines when asked, and even sometimes when not asked. Particularly I would like to thank Ron Richards and Rex Garniewicz of the Natural History Section at the Indiana State Museum, who read portions of this book that addressed topics within their areas of expertise, but certainly not within mine. Their insights and perspectives were most useful. I would also like to thank Jill Costill and her staff in the Manuscript Division of the Indiana State Library, who provided all the images for this book. They proved most tolerant as I looked through hundreds of images, handing me folder after folder of pictures over the course of several weeks last fall. Finally, I would like to thank Jim Kempert and his staff at Arcadia Publishing for giving me the opportunity to work on this project. They provided essential guidance from start to finish.

All photographs courtesy of the Indiana State Library, Manuscript Division.

Front Cover: *"Victory Chest" placed on the south side of the Circle to collect donations for the American war effort in World War I. Such fund drives were common in both World War I and World War II.*

INTRODUCTION

The 2000 U.S. Census lists Indianapolis, Indiana, as the twelfth largest city in the United States, with a population of nearly 900,000 and an area of nearly 400 square miles. In population it is similar to other midwestern cities such as Louisville or St. Louis. In area it is one of the largest cities in the United States and is much larger than either, largely because it lies in a large, fertile plain, unimpeded by large rivers, mountains, or other geographic features. Its origins are also similar to other midwestern cities, in that each was carved out of the wilderness by pioneers seeking a better life in a new land.

But Indianapolis's growth and development were different from St. Louis's or Louisville's because Indianapolis was essentially landlocked; although it was hoped that the nearby White River could be made navigable to the Ohio River. The fact that it could not did not end up a disadvantage. Both St. Louis and Louisville are located on major rivers that allowed them to become major inland ports, but limited their area of growth. Their location along rivers was particularly important in the first half of the nineteenth century when river commerce helped determine a city's growth and prosperity.

During those decades, midwestern products destined for eastern markets traveled the Mississippi and Ohio rivers south, to New Orleans, and then on to eastern cities. St. Louis also had the advantage of serving as a gateway to further exploration of the American West, while Louisville served as a gateway for the settlement of the future states north of the Ohio River.

Yet like St. Louis and Louisville, Indianapolis's growth and development were tied to its location. While not a river city, Indianapolis's location on the Tipton Till Plain allowed it to serve as a focal point for the later development of roads and railroads, both of which provided more efficient and faster access to markets than rivers. At the same time, Indianapolis became a regional

center for manufacturing and industry, again because of its central location and access to new modes of transportation.

As Indianapolis grew in the first half of the nineteenth century, its central location allowed it to serve as a distribution center for Hoosier agricultural products. By 1860, it was the largest city in the state. The tenfold increase in railroad mileage in Indiana during the 1850s also helped Indianapolis to grow as a center of commerce since many rail lines in the state ran through the city.

Faster, more efficient transportation meant that more products could be shipped to more markets. Railroads also tied the state together and allowed people to travel more easily. By the 1880s, the rise of industry utilized the existing rail network to bring in raw materials and ship out manufactured products.

These factors are important to understanding the history of Indianapolis, but they are seldom the subject of study. They also point toward another factor, that Indianapolis is a city that has adapted to the changing economics of the nineteenth and twentieth centuries. As agriculture was replaced by industry as the leading economic force in the early twentieth century, and as railroads replaced canals and roads, Indianapolis adapted to meet the new challenges.

The purpose of this book is to explore these factors of development, change, and adaptation in the history of Indianapolis. It is not, therefore, a comprehensive history of the Hoosier capital. But this approach does have the advantage of placing important events and trends in the development of Indianapolis in their historical context. This book also offers a new perspective in that it focuses on particular trends in the development of the Hoosier capital to explain the broad expanse of the city's history, rather than taking a general approach to frame particular events or trends.

This is a narrative about change over time. From a settlement of a few crude log cabins in 1820 to a metropolitan city of nearly 900,000 people, the key to understanding the history of Indianapolis is to see that it is a story of change and adaptation through time. But there is also continuity in that the city always grew, it never regressed. The city never looked back. The intent of its founders and future leaders was to move forward, prosper, and meet the future head on.

It is also a story of context. No historical event or series of events exists in isolation. Such events would have no meaning if they did. The implication here is that the history of Indianapolis can best be understood within the context of the history of the state of Indiana. I have tried to minimize discussion about state history because this is not a history of Indiana. But when necessary, I have freely discussed state history because it provides greater understanding of the history of the Hoosier capital.

THE SETTING

During the last quarter of the eighteenth century, pioneer farmers were already settling the land that would in 1816 become Indiana. It was a vast, forested land of over 36,000 square miles, roughly three-quarters of which (over 20 million acres) was covered with forests. Wildlife was abundant, including many animals that no longer live in Indiana, such as black bears, wolves, bison, elk, passenger pigeons, Carolina parakeets, and mountain lions. Several thousand Native Americans lived in this land as well, mostly in the central and northern portions of the future state.

For the pioneer farmer, it was a new, largely unexplored land; a land of challenges and opportunities. First, ownership of the land had to be established. Then the trees had to be cut down to make way for farms, towns, and roads. Next, a government had to be established, and land had to be divided and sold. Finally, the Native Americans had to be removed, or at least forced to conform to a different way of life. Most of this was accomplished by 1840.

But this new land, so full of opportunity and resources, was also a very old land; a land that had gone through countless changes over time. For millions of years, the land wasn't even here. Instead, most of the future United States lay near the equator. Continental drift brought the future Indiana to its present position over the course of hundreds of millions of years. For most of that time, the area was under shallow seas, hence the abundant marine fossil deposits that lay exposed or just under the surface in many parts of the present state. More recently the land has gone through repeated glacial periods, when huge sheets of ice moved south from northern latitudes, covering large portions of the state. As these ice sheets, sometimes hundreds of feet thick, moved south and stagnated or melted, they scoured the land nearly flat through abrasive action, especially in the northern and central parts of the future state.

The origins of the glaciers are unclear. Theories range from variations in solar radiation, changes in Earth's orbit, changes in continental position, or climate changes. Most likely, it was a combination of factors. But whatever the

cause or causes, glaciers formed the Indiana we live in today.

Glacial deposits in Marion County range from glacial till, material carried by glaciers (larger, coarser material such as pebbles); to outwash, or material that is washed out by melting glaciers (finer-grained material such as silt). The outwash channels were much larger than the present White River and would have spanned several miles on either side of the present river. Outwash occurred by rivers and streams and Indianapolis itself sits on a 100-foot thick layer of this outwash. Underneath the outwash lies a layer of till that is about 20 feet thick.

Underneath the glacial deposits and reaching down thousands of feet lies the bedrock of central Indiana. Bedrock is not exposed anywhere in Marion County because of the glacial deposits. This bedrock gently slopes southwesterly into the Illinois Basin. First is a layer of Devonian black shale, followed by a layer of Devonian limestone. These layers were laid down more than 250 million years ago. Below these layers lie hundreds of feet of Silurian and Ordovician limestone and other sedimentary rocks. These layers were laid down hundreds of millions of years earlier when Indiana was under a series of shallow seas. For approximately 200 million years, the seas fluctuated in depth until the land was elevated by the rise of the Appalachian Mountains and by plate movement.

There were several periods of major glaciation during the last two million years (the Pleistocene Epoch). Each glaciation was followed by a warmer "interglacial" period, when the ice stagnated or melted, in part or completely. During the interglacials, the climate moderated. Each of the glaciations was named for the present-day state where associated deposits or till are best exposed. The two best defined glaciations are the Illinoian and the Wisconsin.

The Illinoian glaciation began about 220,000 years ago and lasted about 100,000 years. At its height it covered most of the state, reaching far into the hills of southern Indiana. By 70,000 years ago, the Wisconsin glaciation began. Although its ice coverage varied over the next 50,000 years, at its peak about 18,000 to 20,000 years ago, it covered the northern two thirds of present-day Indiana. The non-glacial deposits began to accumulate as soon as the ice melted, resulting in the rich deposits of soil found by pioneer farmers. By 13,500 years ago, the ice had retreated from Indiana completely. The land it left is the landscape of today.

Central Indiana today is called the Central Till Plain, or more commonly the Tipton Till Plain. It is a flat land, scoured by glaciers and covered by rich deposits of fertile soil. It covers over 10,000 square miles and contains some of

the richest farm land in the world. Although much depleted now, largely because of decades of deep plowing, the pre-pioneer soil depth varied between a few feet to as much as 20 feet or more along the Wabash River. The Tipton Till Plain is perhaps best described by Schneider in *Natural Features of Indiana*: "The Tipton Till Plain is a nearly flat to gentry rolling glacial plain, considered by many to be the most typical representation of the Indiana landscape."

Although the Tipton Till Plain appears featureless, it actually contains several end moraines along both its western and eastern sides. End moraines are large, hilly deposits of glacial material that mark the end point of a glacier's advance. Glacial advance was not marked by an even line of ice; rather, "lobes" grew and receded unevenly. The end moraines generally run from northeast to southwest and indicate the direction of the glacier's advance.

Another clue of glacial path can be found on rocks with striations that indicate the same northeast to southwest direction. No such rocks exist in Indiana, but scientists do know that three lobes moved into Indiana during the Wisconsin glaciation. They were the Lake Michigan Lobe, the Huron-Saginaw Lobe, and the Ontario-Erie Lobe, which was the closest lobe to Marion County. The Wabash River roughly defines the northern limit of the Tipton Till Plain, while the hills of southern Indiana mark the southernmost advance of the Wisconsin glaciation. The area between the Wabash and the hills of southern Indiana defines the geographical area of the Central or Tipton Till Plain.

The main feature of Marion County, besides its flatness, is the White River. It enters the county on the north side and flows southwest, passing along the west side of downtown. Fall Creek enters the county east of White River and joins the White River at 10th Street in the downtown area. The other major feature of Marion County is a depression called Pogue's Run. Within it lies a small stream that cuts across the southeast part of the mile square. For years after settlement, it was a malaria infested swamp. It wasn't until the early twentieth century that storm sewers drained enough of the swamp to make settlement along it safe from malaria.

When the last glaciers retreated 13,500 years ago, humans had not yet moved into Indiana. Some animal species such as mammoths and mastodonts would soon become extinct, while others such as caribou had moved north and west. Other species remained, however, such as white-tailed deer and groundhogs. Soon afterward, humans began to move into the region. The

first occupants of Indiana and the only people to live here for millennia were tribal groups from Asia. They left no written records and are defined only by their cultural remains. They are often named for the sites where archaeologists have found these remains. These prehistoric peoples were not the same people who greeted the first white men in the late seventeenth century. Those were historic tribes; Native Americans known through written records.

Archeologists have defined four major periods of prehistoric occupation in Indiana: Paleo-Indian (from 10,000 B.C. to 7,500 B.C.), Archaic (from 7,500 B.C. to 1,500 B.C.), Woodland (from 1,500 B.C. to 1200 A.D.), and Mississippian (from 1200 A.D. to 1450 A.D.). These dates are approximate and serve mostly to define similar cultural patterns. They are also very fluid and vary from location to location. It is best to look at them as cultural periods rather than chronological periods. The further back in time, the less exact the dates.

Within the Archaic, Woodland, and Mississippian periods, there are further subdivisions based on changes in subsistence patterns and technology. There also is considerable overlapping between cultural periods so that the Late Paleo-Indian period can be difficult to distinguish from the Early Archaic period. Closer to our time, the Late Woodland can be difficult to separate from Early Mississippian at some sites. That is why the transition from Late Woodland to Early Mississippian is sometimes referred to as Late Prehistoric.

A good example of this is the Bowen Site in the northern part of Marion County, where pottery styles combine decorative motifs not seen elsewhere, and where other aspects of the site share characteristics of both Late Woodland and Early Mississippian culture. The Bowen Site is one of seven sites along the White River in Hamilton and Marion Counties. Together, they are referred to as Oliver Phase sites because they have characteristics of both Late Woodland and Early Mississippian sites. For the Bowen Site, the time frame begins sometime after 900 A.D. The Bowen Site sits on a glacial outwash north of White River and east of present day Keystone Avenue. The site covers approximately three-quarters of an acre. There is no evidence that the Bowen Site was a permanent habitation, but many artifacts have been found indicating at least seasonal occupation including pottery shards, worked stone, mussel shells, projectile points, and animal bones. Forty-two burials also dot the site. Archaeologists have determined that the Bowen Site people were the first agricultural people in central Indiana. They grew corn, beans, and squash. They also hunted deer, raccoon, bear, and elk, among other animals. The Bowen people lived within a circular stockade,

possibly to guard against hostile neighbors. The reason for such hostility is not clear, but it may be that increasing populations led to conflicts over land and resources. They were moderately healthy, as skeletal remains indicate life spans into the forties.

Despite the overlapping and the approximation of dates, each of the four major periods of prehistoric occupation has defined characteristics that separate them from one another. These are factors of continuity, change, and adaptation. These factors will appear again and again as the story of Indianapolis and central Indiana unfolds.

Because there was so little physical evidence left by Paleo-Indians, it is difficult to make definitive statements about how they lived. But the evidence that does exist indicates that Paleo-Indians appeared shortly after the Pleistocene ended, after the glaciers receded and the land opened up for occupation and exploitation. It is also certain that their lives would have undergone change as they adapted to a progressively warmer climate. They were primarily hunters of large mammals and gatherers of native food plants. They were essentially nomads, moving from site to site, rarely staying more than a few weeks. No intact Paleo-Indian occupation sites have been found anywhere in Indiana. What physical evidence exists consists primarily of projectile or spear points with distinctive fluting on both sides. These spear points have been found on the surface and in plowed fields. From other sites found outside Indiana, the evidence indicates that Paleo-Indians hunted large mammals such as mammoths and mastodonts, as well as smaller animals like turtles and birds. It is likely that similar activity occurred in Indiana as well, but no spear points have been found in conjunction with any mammal skeletons. Paleo-Indian spear points have been found in many Indiana counties, mostly in the southern part of the state. It is likely that they occupied central Indiana as well.

After the Pleistocene ended, about 13,500 years ago, the climate continued to warm for several thousand years. Continuing changes in climate, forest composition, and animal and human occupation also occurred. Large Pleistocene mammals such as mammoths and mastodonts became extinct because of environmental change, hunting, or both. The next human occupants, called "Archaic" peoples, were also hunter-gatherers with hunting a primary source of their food and clothing, but carbonized plant remains at some occupation sites indicate that native plants were an important food source. Several intact occupation sites have been found in

Indiana that indicate their occupants lived longer at these sites, although Archaic peoples were still largely nomadic. This more sedentary lifestyle may indicate that Archaic peoples enjoyed more secure and plentiful food sources. Among these was nutmeat from the hickory tree, which appeared after the Pleistocene ended and the Holocene began. Their spear points are also different from the Paleo-Indian points in that they are notched on either edge near the bottom, as contrasted to the Paleo-Indian points that are fluted for hafting. Archaic points are found in upland areas of southern Indiana and in river valleys.

By Middle to Late-Archaic times more sedentism is found, lasting seasons rather than weeks. Since many of these sites are found near rivers, large shell mounds or shell middens have been found near the sites as well. An important factor that distinguishes Archaic peoples from Paleo-Indians is that Archaic occupation sites show evidence of burials. These burials contain artifacts that may indicate either high social or political status of those interred. One problem with determining what the burial goods represent is that the goods change over time from egalitarian to achieved status to inherited status. But in the absence of written records, it remains difficult to determine what the burial goods indicate. Another possibility is that these artifacts were placed in graves to accompany the dead in the afterlife.

Sometime around 1,000 B.C. ceramic vessels began to appear, signifying the end of the Archaic and the beginning of the Woodland period of prehistoric occupation. The first pottery vessels found are called Marion Thick, after a site in Marion County. Early ceramic vessels were utilitarian; that is, they were made simply for carrying water or storing food items. Decorative vessels did not appear until later.

During the Early and Middle Woodland another characteristic emerged that distinguished this period from earlier prehistoric cultures: the construction of large burial mounds. These mounds are found in southern Ohio, central Indiana, and southern Illinois. Artifacts found within these mounds again indicate a higher social or political status for their occupants. In some cases, wooden enclosures and temples were built on top of the mounds, indicating that religious ceremonies were probably held there.

A third distinguishing factor of the Woodland period is that artifacts from different regions appear in the occupation sites, indicating that trade was occurring between groups of prehistoric peoples who lived hundreds of miles apart. There was still no practice of agriculture as we know it; hunting

and gathering were still the primary methods of attaining food. But certain plants were being selected and cultivated, indicating a greater reliance on the gathering of food supplies.

By about 1000 A.D., during the Late Woodland, the building of burial mounds ended for unknown reasons. There were other changes as well. Over the previous centuries, maize cultivation emerged as a main food staple. The bow and arrow replaced the spear and the points became smaller and triangular, probably to facilitate the more efficient use of the arrows. These changes occurred between 700 and 900 A.D.

The Woodland period did not end abruptly, but rather overlapped at different times in different places with the Mississippian period, which began around 1000 A.D. This was the final phase of prehistory and lasted until about 1450 A.D. Mississippian settlements were larger than in previous periods and were fortified, possibly indicating a need for protection from attack by other settlements. Intensive maize agriculture was practiced, although hunting probably still supplemented the diet. Besides maize, beans and squash were grown. Fishing also was an important source of food supplies. The typical agricultural practice was to clear a field by burning and then use the field until it became unproductive, when another area was selected and the process started again. For smaller populations this was an adequate method of food production, but for larger populations this quickly became impractical because the fields ended up further and further from the main village. The larger populations that came later required a more intensive type of agriculture, where the same fields were used over a period of years. It was not uncommon for smaller villages to surround the larger village, as populations expanded and drew on the resources and defenses of the larger villages.

The first white men to enter the future state of Indiana were French fur traders. By the time they arrived, in the last decades of the seventeenth century, the Native Americans they met and traded with were not Mississippian or any other prehistoric group. Those cultures had disappeared by the mid-fifteenth century. Whether the Native Americans who met the French were descendents of the Mississippians is uncertain. The Caborn-Welborn people, for example, lived in the same general area as the Mississippian people, but their villages were much smaller. There are also aspects of Miami culture that seem to parallel Mississippian culture. For the most part, historians do not know what occurred in Indiana between the end of the Mississippian Culture in the mid-fifteenth century and the entry of the first white men in the late seventeenth century.

When the French explorer Robert de La Salle entered Indiana in 1679, there were perhaps a dozen tribes living in Indiana. The total Native-American population is unknown, but estimates range from a few thousand to several tens of thousands. The Delaware and Shawnee, who would arrive about a century later, were pushed west into Indiana by white expansion. Others, such as the Miami, Kickapoo, and Potawatomi, came south from the Great Lakes region, pushed by the Iroquois expansion. All spoke Algonquin languages. Most numerous were the Miami, who lived around the southern end of Lake Michigan. The Miami were already in Indiana when La Salle portaged through the northwest part of Indiana in 1679. Shortly before the American Revolution, the Potawatomi and Delaware moved into the state. The Delaware settled in the east-central part of Indiana. The Miami occupied the northern part of the state. The Shawnee lived both in the northern and southern parts of the state.

It is unclear what Native American tribes, if any, were actually within Marion County during the early historical period (after 1679). But within the general area were the Miami and other tribes who spoke central Algonquin languages. Kikapoo, Shawnee, and Potawatomi were also in the area during the eighteenth century. The Miami claimed the area during treaty negotiations of the late eighteenth and early nineteenth centuries, but there are no records of any specific habitation within Marion County. It was not until the early nineteenth century that Delaware villages were documented along the west fork of the White River. It was the Delaware who greeted the first fur trappers and traders in central Indiana.

The French fur traders came down from Canada to exploit the resources of the unsettled and unexplored lands west of the Appalachians. Their intent was not to colonize but to exploit the rich, untapped resources. Even though their effects on the land and its inhabitants was less than that of later English and American settlers, changes had begun that would forever alter the land and the cultures of its inhabitants. The French had few settlements in Indiana because their goal was not to settle, but to expand their sphere of influence through the exploitation of the fur trade. Although they stayed for less than a century, their effect was profound because they set the pattern for the future occupation by the English, and more importantly the Americans, who never left.

During the first half of the eighteenth century, the French expanded their presence by establishing a series of forts that also served as trading posts.

Competition with British traders and ever-shifting alliances with various Native American tribes caused increased tensions that led to the French and Indian or Seven Years War in 1756. It was the last of several European wars between the French and British over dominion in the New World. With the French defeat in 1763, the British took possession of the lands north of the Ohio River and between the Appalachian Mountains on the east and the Mississippi River in the west.

Like the later American settlers, the British were met with several problems when they took possession of the Northwest Territory. Among these were how to govern the vast territory, how to deal with the myriad of Native-American tribes, and how to regulate any future settlement. The fur trade continued to have a major effect on Native-American culture because tribes became more and more dependent on trade with white men, pulling them away from their dependence on the land and its resources. A widespread Native-American rebellion in 1763, known as Pontiac's War, led the English to issue the Proclamation of 1763, which limited white settlement in the region. It also regulated the fur trade.

But the Proclamation of 1763 did not stop or even slow the settlement west of the Appalachians. By the 1770s, Native Americans had begun to cede land in the future states of Pennsylvania and West Virginia to the British. Civil government came to the region when the Northwest Territory was annexed to Quebec in 1774. As more settlers moved into the region, another war erupted in 1774, known as Lord Dunmore's War. During the next several years, the American Revolution in the West played out in the southern swamps of the Ohio Valley, as George Rogers Clark and his men harassed the British, diverting their attention from the larger concern of stopping General Washington in the east.

After the signing of the Treaty of Paris in 1783, which ended the American Revolution, the British ceded the lands north of the Ohio River and east of the Mississippi River to the new nation. Two important ordinances, passed by the Confederation Congress, made possible the orderly settlement of the Northwest Territory. The first was the Land Ordinance of 1785, which determined how the land would be divided and sold. The second was the Northwest Ordinance of 1787, which determined how the land would be governed.

Prior to the Land Ordinance of 1785, land was surveyed and sold by the old "metes and bounds" system, where measurements were taken based on physical features of the land such as trees or rocks. This method proved inaccurate and land disputes were common. The Land Ordinance of 1785

established a consistent system, known as the United States Congressional Township and Range System. This system used a series of imaginary vertical and horizontal lines to establish six-mile squares called Congressional Townships. Each township in turn was divided into 36 one-square-mile sections, each of which contained 640 acres. The sections were then marked from 1 to 36, starting with the upper right-hand section, moving left and then down to the next row, moving right to the end and down to the next row and moving left, until the end of the township. Section 16 was set aside for schools. This method of surveying and dividing the land for sale remained in effect until the entire region was surveyed and sold.

Although the Land Ordinance of 1785 was a relatively simple system, there were problems. One was the high price of land. At a minimum of one dollar per acre with a minimum sale of one section, $640 frequently was too much for most settlers to afford. This problem was solved in 1800 with the passage of the Land Act, which reduced the minimum size of parcels settlers had to buy. Another problem was that there were no land offices in the Northwest Territory; all land sales were held by auction in the East. Eventually land offices were established in a number of cities such as Vincennes, Crawfordsville, and later, Indianapolis.

Equally important to how the land would be divided and sold was how the land would be governed. The Confederation Congress envisioned that between three and five states would be created and allowed to enter the United States on an equal footing with the other states. Eventually five states were created from the Northwest Territory: Ohio, Indiana, Illinois, Michigan, and Wisconsin. But it had not yet been decided how to acquire the land from the Native Americans who had lived there for centuries. As more settlers moved in, many as squatters, Native-American resistance to the Americans increased during the 1780s and 1790s. In 1794 General Anthony Wayne defeated a Native-American confederacy at Fallen Timbers, effectively ending Native-American resistance until the early nineteenth century. In 1795, the Native Americans ceded to the new American government most of Ohio and a sliver of what would become part of eastern Indiana known as the Gore. This was the first of more than two dozen treaties that ceded the lands that would become the future state of Indiana to the government between 1795 and 1840.

Following the conflicts of the late eighteenth century, the process of statehood began in the Northwest Territory with the separation of the

future state of Ohio in 1800. The rest of the territory became the Indiana Territory and entered the first stage of territorial government. The Northwest Ordinance called for a three-stage process whereby territories became states. The first was a non-representational stage where government was carried out by an appointed governor and three judges. Beginning in 1787, the entire Northwest Territory entered this first stage. The second was entered when a territory attained a population of 5,000 free, white males. This second stage was representational, but still ruled by the governor. Those owning over 50 acres of land elected a lower house, from which a territorial delegate was sent to Congress to represent the interests of the territory. The delegate had no vote, however. The national government still appointed the upper house during the second stage, and the territorial governor still maintained a veto over any legislation passed by the lower house. When a territorial population reached 60,000, the legislature could petition Congress for an enabling act. This third stage was the final step toward statehood, beginning with the passage of the enabling act, the approval of a written constitution, and entry into the Union.

A NEW CAPITAL

The decision to locate the new state's capital in the swampy wilderness of central Indiana was a calculated decision, based on the assumption that the continued settlement of Indiana would necessitate a more centrally located city. That had been the case when Vincennes was named territorial capital in 1800, and it also had been the case when the territory entered its second stage of governance and the territorial capital was moved to Corydon in 1813. The decision to place a new capital in central Indiana was not without controversy, however, given the conditions in central Indiana, the lack of access to the area, and the fact that central Indiana was still occupied by Native Americans. Locating the capital so far away from the population centers in southern Indiana also sparked a political debate between various towns that wanted to host the new capital.

Although political parties did not exist in Indiana in the early nineteenth century, there were political factions that represented opposing points of view on the important issues of the time. One faction was represented by Territorial Governor William Henry Harrison and centered on Vincennes. Harrison had come from a distinguished Virginia family; his father had been a signer of the Declaration of Independence and governor of Virginia. Harrison had come to the Northwest Territory as a young officer and served under General Anthony Wayne and under Territorial Governor Arthur St. Clair. He served as secretary of the Northwest Territory and was the territory's first delegate to Congress. In 1800, he was appointed governor of the newly created Indiana Territory. Soon after assuming office, Harrison came into conflict with the southeast faction that favored a faster process toward statehood. Harrison was opposed to early statehood and was slow to act when opposing politicians tried to move the territory more quickly into the second or representational stage of territorial government. This faction was led by Jonathan Jennings, who would later become Indiana's first governor. Jennings had come from Pennsylvania in 1806 and quickly established himself as a leading citizen in Vincennes by 1807. In 1808, he assumed a leadership role of the southeastern faction that

opposed Harrison's views on several issues, including statehood and the role of slavery in the territory and future state. In 1809, when the Indiana Territory was split off from the Illinois Territory (that included the future states of Illinois and Wisconsin), Jennings became the Indiana Territory's non-voting representative to Congress. There he pressed for early statehood, a position Harrison opposed. In 1816, Jennings served as president of the Corydon constitutional convention. But by 1812, Harrison had resigned his position as territorial governor and joined the war effort against England.

Both Harrison and Jennings were Jeffersonian Republicans. Harrison represented the faction that was more tolerant of slavery, while Jennings came from the part of the state more influenced by the Quaker anti-slavery view. The slavery issue would continue to be a major factor in politics until the state constitution was written in 1816. The Northwest Ordinance prohibited slavery in the territory and in the new states that would come out of it. Those people holding slaves were allowed to keep them. In 1803, the territorial legislature adopted a Virginia law that allowed indentured servitude for life. While this law did not specify slavery, it was essentially the same thing. In 1805, the legislature re-affirmed the law, but by 1810 it was repealed. When the new state constitution was written in the summer of 1816, it was specific in prohibiting slavery in the new state.

The process of statehood actually began in 1811 when the territorial legislature petitioned Congress for an enabling act. Congress denied the petition, stating that the request was premature. Indiana's population was still far below the 60,000 required and the territory had virtually no sources of income to fund a state government. The War of 1812 postponed the effort until 1815, when the territory again petitioned Congress. Although Indiana only had 15 counties, its population had by then exceeded the 60,000 required for statehood and in 1816 Congress authorized an enabling act that called for a convention in Corydon to draft a constitution. After the constitution was drafted, state officers were elected and a state government was organized that fall. By December 11, 1816, the organizational phase was completed; Congress accepted the constitution and Indiana was admitted as the nation's nineteenth state. While borrowing heavily from the Ohio constitution, Indiana's constitution was a progressive document, allowing universal suffrage for white males, excluding slavery, and providing for an educational system. The general assembly was to meet annually for as long as was necessary to deal with the business of a new state.

Selecting a site for the new capital was a process established by the new state legislature. It began in 1818 in St. Mary's, Ohio, when chiefs of the Delaware, Miami, and Potawatomi tribes relinquished control of central Indiana in a treaty called the New Purchase. This 8-million-acre central third of Indiana was to be vacated by the resident tribes within three years, allowing for the orderly settlement of central Indiana and the establishment of a new capital somewhere near the center of the new state. One of the three commissioners who negotiated that treaty was Governor Jennings, who had long been an advocate of the opening up of central Indiana, reasoning that a centrally located capital, near a navigable river, would be more easily accessible to the growing population no matter where they lived in the state.

But determining who owned the 8 million acres of central Indiana was not easy. The Miami tribe originally occupied and claimed the land. The Piankashaw also had claim to some of the land, but sold their claim to the Delaware tribe who had come west seeking a new home from the expanding white population in the east. But there still was a dispute between the Miami and the Delaware over the extent of the Delaware claim. Territorial Governor William Henry Harrison intervened and at the Treaty of Fort Wayne in 1809, a settlement was reached whereby each would attain the consent of the other when any land was sold. Nine years later, the tribes gathered at St. Mary's, Ohio, where the Delaware gave up their claim to their lands in Indiana. Most of them moved west by 1821 but a few Delaware remain in Indiana today. The Miami also ceded their lands between the Wabash River and the southern counties. Government surveying began immediately after this cession.

Settlers were pouring into Indiana at a rapid rate. But before statehood, they had been confined to the southern counties, along the Ohio River. Within five years after statehood, they had access to the vast, forested lands of central Indiana. Nevertheless, there was opposition to locating a capital so far away from the major towns of southern Indiana, such as Madison and Corydon. Residents of Corydon, the capital since 1813, feared the loss of revenue and influence if the capital was moved so far away. Yet Corydon itself was not easily accessible unless one came via the Ohio River. It was surrounded by hills with few nearby roads. Residents of Madison, the state's largest city and a major pork-packing center, also wanted the capital in their city. Other towns resented the fact that they had no role in the decision. But central Indiana offered many advantages. For one, a new capital could be planned to take advantage of the vast natural resources to be found in central Indiana. A second reason was that

a capital located on or near the White River would give the central part of the state a chance for rapid and sustained growth by using the river to transport products and raw materials. A third advantage was that selling plots within the four sections of land given to the state by the federal government would provide funding for the public buildings needed for the new capital.

On January 11, 1820, the state legislature authorized Governor Jennings to appoint a commission of ten men to select a site within the New Purchase for the new capital. Representatives were selected from Wayne, Fayette, Dearborn, Switzerland, Clark, Harrison, Jackson, Posey, and Knox counties. The representative from Gibson County did not serve on the commission. The commission was charged "to meet at the home of William Conner on the West Fork of the White River . . . and proceed to select a site which, in their opinion, shall be most eligible and advantageous for the permanent seat of government of Indiana." The commission gathered on May 22 at Conner's farm, located about four miles south of present day Noblesville and 16 miles north of the future capital, and surveyed three sites including Conner's farm, the Jacob Whetzel settlement, and the Fall Creek settlement at the confluence of the White River and Fall Creek.

William Conner had lived on the prairie near a bend of the White River for about 20 years. The son of Moravian missionaries, William and his brother John had come down the White River in 1800 to trade with the Delaware tribe who lived in scattered villages along the river. William had married the daughter of Chief Anderson and built a cabin and a trading post on the river. There he began to farm the prairie and expand his trading activities. By mid-century he was one of the wealthiest men in the state.

Jacob Whetzel's farm near Waverly also was close to the White River, located at the end of a trace, or road, that started in Laurel in Fayette County and cut across 60 miles of forest through the future Rush, Shelby, and Johnson counties. Whetzel had come from Kentucky in 1811 and settled near Laurel in the Whitewater Valley. After serving in the War of 1812, Whetzel bought land in Greene County but found the travel difficult between Greene County and Laurel. After receiving permission from Chief Anderson, Whetzel, his son, and others cut a trace in 1819; the first east-west trace in central Indiana. Whetzel began to clear and farm his land and hoped to build a settlement on the bluffs overlooking the White River.

On May 24, the commission inspected the third site, east of the confluence of Fall Creek and White River on a flat plain. The earliest residents there were

the Pogues and the McCormicks. Both families were on site by the spring of 1820. George Pogue had been a blacksmith in Connersville before moving his family to Fall Creek. There he built a large cabin for his family of seven and had begun to clear the land for farming when the commissioners arrived on May 24. Before building his cabin, however, Pogue lived in a cabin previously occupied by Ute Perkins, who came to the area from Rushville as early as 1819. The McCormick family also had arrived in that spring of 1820, coming part way along the Whetzel Trace. Their cabins were located on the banks of the White River north of the future Washington Street. For generations there has been a debate among historians and family members of the Pogues and the McCormicks as to which family came first to the Fall Creek site. The Pogues always claimed that they came in the spring of 1819, making them the first residents. Both families have presented their evidence for scholars to analyze, but over the generations it has become nearly impossible to separate fact from family tradition.

By 1820, other families had arrived as well. Most were farmers, some were squatters. In all, about a dozen families lived on site by May of 1820. After inspecting this site, the commissioners spent several days discussing their options. Part of the reason the site near the McCormick cabin was chosen was that the White River was seen as navigable and a vital component to the growth of the new city. The site was also very flat, which would make building the city easier. Another reason for choosing this site was that it was close to the proposed National Road, which originally had been planned to pass south of the city. After making its decision, the commission reported to the legislature on June 7, 1820. In early 1821, the legislature accepted the decision of the commission and set about naming the new city. A number of suggestions were rejected before the name Indianapolis was accepted. Among them were "Tecumseh," suggested by Marston Clark of Washington County, and "Suwarrow" and "Tuwarrow." Judge Jeremiah Sullivan of Madison suggested the name "Indianapolis," meaning "city of Indiana." Although the name was widely criticized, no other name was any more popular so the legislature adopted it as the name for its new capital.

Indiana had its new capital, but in name only. There was no city yet. A few families had already settled on the site, but there were no legislative or public buildings. The nearest settlement, Connersville, established by William Conner's brother John, was 60 miles away. But the site had been selected and named, and the legislature determined that within five years the capital

would officially move from Corydon to the new city on the White River. The next step was to take advantage of the fact that there was no city there yet. The opportunity existed to design a new city, exactly what Governor Jennings had wanted.

A second commission of three men selected by the legislature was appointed to plan the new city. This commission was led by Christopher Harrison of Salem, a wealthy politician who had been lieutenant governor under Jonathan Jennings. In this position, Harrison had attempted to have himself proclaimed governor when Jennings took a position on the site selection commission. Having failed in this attempt, Harrison resigned. His commission selected Elias Fordham and Alexander Ralston, also of Salem, to design the new city.

Ralston had assisted Pierre L'Enfant in the design of Washington, D.C. L'Enfant had been influenced by the symmetry of the Versailles palace, and Ralston was no doubt influenced by L'Enfant. The similarities between the designs of Washington and Indianapolis are apparent. Both are symmetrical and radiate from a central point with diagonal avenues. The entire plat for the capital city was to be one mile square, set in the center of the four section grant given by the federal government. The plat is actually slightly off-center because it was moved to avoid encompassing part of the Pogue's Run depression. The design called for nine north-south streets and nine east-west streets. Each street was to be 90 feet wide. The original intent was to have the square mile bordered by North, South, East, and West Streets, but these streets don't appear in the original plat and were added later.

The four center blocks were called the Governor's Square. Planned for the center of the city was a three-acre circle where the governor's residence would be built. This residence was erected in 1827, but no governor ever lived there. The building did see other uses, but fell into disrepair and was eventually torn town in 1857. The street surrounding the circle was designed to be 80 feet wide. Running north and south through the center of the city was Meridian Street. Market Street was to run from east to west, through the circle. Diagonally radiating from the Governor's Square were four main avenues: Indiana, Kentucky, Virginia, and Massachusetts. Parts of all four still exist today, but extensive downtown rebuilding has eliminated most of the original avenues. The first street south of the center acreage was called Washington Street and was seen by Ralston as the main street of the new city. It was designed to be 120 feet wide. Blocks also were set aside for a capital building and a courthouse. It was a plan of foresight, and a plan of tradition. But it was

only a plan. Trees had to be cut down, streets created, buildings constructed, and the malaria infested swamps drained.

The population grew rapidly in those first years in Indianapolis. By the time the capital moved from Corydon in late 1824, several hundred people had made their way to the new city in the wilderness. Because there were few roads, people came on foot, by horse, and by wagon, cutting new trails along the way. They came from different places, but mostly via the Ohio River from Kentucky, from the mid-Atlantic states, and from the Upland South. They had different plans and desires, but most of them sought prosperity and a new life in a new land. The challenges were formidable and the conditions at times were appallingly difficult, but the rewards could be great as well.

Among the new arrivals were farmers, like the Pogues and the McCormicks, who made their living off the land. In fact, most of the early residents were farmers, because the city barely existed beyond its name. There were few businesses and little commerce. But others soon came to be part of the new city: businessmen, ministers, teachers, doctors, and craftsmen. They all would be needed for the new city to thrive and grow. Nor was there any local government to speak of yet. But in that first year of 1821, the state legislature in Corydon took the first steps toward establishing local government.

On December 31, the legislature established Marion County with Indianapolis as the county seat. Marion County was named after Francis Marion, the Revolutionary War general who had earned the nickname "Swamp Fox" by his ability to strike at the British and disappear into the swamps. Edward Leary, in his *Indianapolis: The Story of a City*, makes note of the irony that the county was named after a person whose nickname aptly described the conditions faced by the early settlers of Indianapolis. The state legislature also appropriated $8,000 to build a county courthouse. A judge and a sheriff were appointed and plans were made to build roads to make settlement easier. One such road would come from Madison, the state's largest city, while another would come from Lawrenceburg. Although Marion County was approximately the same size as it is today, the future counties of Johnson, Hamilton, Hancock, Madison, and Boone were included within the judicial district.

Despite the optimism and progress already made, there was also tragedy that first year. It was a typically hot and humid summer, made worse by the swamps and stagnant Fall Creek. The area became a breeding ground for millions of mosquitoes. People began to fall ill with symptoms similar to malaria: chills, high fever, and weakness. Malaria was not uncommon under

such conditions in early Indiana. At the time the cause was unknown, but was attributed to the decaying vegetation and stagnant pools of water in Fall Creek. Early nineteenth-century medicine did not know that the mosquitoes were the carriers. With only two doctors to treat hundreds of sick settlers, and with little effective medicine, the task was daunting. By the time the affliction subsided in the fall, about one in eight residents had died. After it was over, some people moved to higher ground, while others left the city altogether.

For those living in Indianapolis in the fall of 1821, it must have seemed doubtful that the city would grow much after the season of hardship and death they had just survived. They probably were not optimistic when it was announced that the first sale of lots was planned for the second Monday in October. Alexander Ralston's plan for the city called for lots to be established and sold for homes and buildings. The date set was October 9, but only one lot was sold that first day, one on the south side of Washington Street that went for a little over $150. By the end of the week a total of 314 lots had been sold with cash receipts of about $7,000. The remainder, in promissory notes, was due within four years. Many lots remained unsold for years. In fact, it was not until 1842 that all the lots were sold. Over the next several years the proceeds were used to build government buildings including the court house, the governor's mansion, the clerk's office, and the state treasurer's office.

On January 28, 1824, the state legislature, still meeting in Corydon, passed a bill authorizing the transfer of the capital functions to the new city on the White River. Though not a popular decision to the citizens of the southern counties, the bill passed. It mandated that the next session of the legislature meet at the new Marion County Courthouse on January 10, 1825.

Preparations for the move from Corydon to Indianapolis were under the supervision of Samuel Merrill, the state treasurer. The entire contents of the state capital, including the state treasury, other important records, and the printing presses, fit into four wagons. Fourteen people made the journey in November of 1824. The trip was expected to take about one week but actually took nearly two weeks, largely because of the terrible road conditions. In some places there were no roads at all and trails had to be hacked out of the forests before the wagons proceeded. The party consisted of Merrill and his family, the state printer and his family, and a Mr. Seibert, who had provided the wagons. While they were sometimes able to make 20 miles a day, the conditions were so bad that on some days, only a few miles could be managed.

Both mail delivery and newspaper publication began even before the formal move of the capital from Corydon to Indianapolis. Mail delivery began in 1822 when Aaron Drake began monthly deliveries from Connersville. By June of 1823, other routes were established from Madison and Brookville. The first newspaper was published in a log cabin in January 1822 and called the *Gazette*. Its name was changed to the *Democrat* in 1830 and the *Sentinel* in 1841. It remained the main Democratic Party organ until 1906. The *Western Censor and Immigrant Guide* started in 1823. Its name was changed to the *Indiana Journal* in 1825 and later to the *Indianapolis Journal*. It remained the main Whig and Republican Party newspaper until 1904. Throughout the nineteenth century, newspapers functioned not only as sources of information but also as the partisan voices of political parties. In the absence of radios, televisions, or computers, newspapers were one of the most effective ways of communicating information and ideas during the early years of statehood.

THE FIRST YEARS

The years between 1825 and 1850 were years of growth and development in Indianapolis. In just one generation, the city went from a frontier village to one of the largest cities in the state. In 1825, less than 1,000 people lived in the new capital city. There were few streets or business establishments. The majority of the residents were farmers who supplied most of their own needs. There was little surplus or the ability to create it for sale in markets. That would change in this generation. The few streets that existed were hardly passable by today's standards: tree stumps could be found everywhere. When it rained, travel was nearly impossible as the dirt streets turned to mud. There were no major roads into or out of the city. Travelers came to Indianapolis on foot, horseback, or by wagon, sometimes hacking new trails along the way. Most of the residents lived in cabins scattered throughout the woods surrounding the few main streets of the city. Indianapolis may have been the capital of Indiana, but it was still very much an isolated, frontier town.

Most of the early pioneers practiced subsistence agriculture, which meant that they consumed most of what they produced. After acquiring the land, the first task of the pioneer was to build shelter for his family. This could be a simple open-faced shelter (facing south), or a simple one-room log cabin that would allow the family to survive the first winter. Because the pioneer brought with him only the most essential tools, this initial shelter was simply constructed, as was the furniture within it. A small crop of corn and a small vegetable patch might also be planted near the cabin. The next step was to begin clearing the land and preparing the ground for planting. The felling of trees could be a long and arduous task, often taking years to complete. Sometimes the trees would be girdled (cutting away the bark and topmost layer of tissue in a band around the tree) and left to die on their own. Or the trees would be felled completely. They were then piled up and burned or sometimes used to build cabins, mills, barns, or other structures. Tree stumps also

had to be cleared, but this was less important initially because small corn patches could be planted between the stumps. Despite the romantic portrayals of husband, wife, and children felling trees, burning logs, and clearing stumps with the help of horses or oxen, pioneer families did not live in isolation. Isolationism would have defeated the very purpose of pioneering, which was to build new lives and new communities. Nearby pioneers would help with felling, burning, and clearing of farm land. This was called log-rolling, and served the incipient community by bringing families together as well as helping the immediate needs of the individual family. This community help aided all pioneers and helped communities to grow and prosper more quickly.

Once cleared, the land had to be broken and made ready for plowing. Depending on the soil type, it could be jump plowed (jumping over the larger impediments) or broken with a conventional wooden or iron plow. The soil clumps would then be broken further with a harrow (a spiked or pronged sled pulled by horses or oxen). The crop of choice for most pioneers was corn, as it had been for Native Americans. Corn grows easily in a variety of soils and climates, quickly produces a surplus, and provides a variety of food for humans and feed for livestock. Pioneers also brought hogs with them or bought them soon after arrival. Hogs would be allowed to forage for their own food throughout the growing season, but were penned up and fattened a few weeks before going to market, which usually occurred after the fall harvest. While much of the pork would go to market, the pioneer farmer would keep as much as could be salted, smoked, or preserved for the winter. Soon after establishing a homestead, pioneers planted vegetable gardens as well. Cabbage, peas, pumpkins, turnips, peppers, tomatoes, potatoes, beans, and onions were the most commonly planted vegetables. A successful pioneer farmer quickly produced more than his family could consume. This surplus was sold or traded to other farmers or at community markets.

By 1850, the village had become a city. The National Road, the nation's first east-west highway, came straight through the city along Washington Street. The Michigan Road, the state's first major north-south road, also came through the city on its way from Madison to Michigan City. The Central Canal, part of the 1836 Mammoth Internal Improvements Act, came through the west side of downtown on its way south. But it proved of little value because it was never finished, due to the collapse of the Mammoth Internal Improvements program and because railroads were already starting to prove

more efficient and profitable. Within ten years, the amount of railroad mileage increased tenfold. Businesses of all types were thriving, from bookstores to millenary shops. A manufacturing base had been established, largely through agricultural surplus; though agriculture continued to dominate the economy and would continue to do so until after the turn of the century. Between 1850 and 1860, the population would more than double to nearly 20,000, making Indianapolis the largest city in the state. Its central location on a large, fertile plain made these changes possible. In the future, location would continue to be a major factor in the growth and development of Indianapolis.

The first generations of Indianapolis residents came from many places, including other nations. In the first years of settlement in southern Indiana, most of the settlers came across the Ohio River from Kentucky, Tennessee, and other states in the upper south. For the most part they were non–slave holding farmers who brought their farming traditions with them. After the Treaty of St. Mary's, signed in 1818, central Indiana began to open up to these same settlers from the southern states, including the Carolinas. The northern part of the state also offered rich agricultural opportunities. But because of the lack of roads and the swampy terrain in some parts of the north, it was the last region of the state to be settled. The soil type in the northern part of the state was also more root-bound and those lands were not effectively farmed until the invention of harder plows, such as the Oliver Chilled Steel plow, introduced in the mid-1850s. By the time the northern lands were opened up, settlers also came from the New England states, though in much smaller numbers.

Equally important to the migratory waves from the eastern and southern United States were the immigrants who came from other countries, starting in the 1830s. Tabular data from *Peopling Indiana* shows who these immigrants were, where they came from, and where they settled. For example, in 1850, over eight percent of Marion County residents were immigrants; nearly 2,000 out of a population of just over 24,000. By 1860, in Indianapolis alone there were over 5,000 foreign born, out of a population of nearly 19,000.

Among the foreign born in large numbers were the Irish, fleeing harsh economic conditions at home and seeking a new, better life in America. Initially they came to work on the National Road and the Central Canal. The Irish constituted the second largest group of immigrants, next to the Germans. After the collapse of the Mammoth Internal Improvements

program in the late 1830s, many of the workers found themselves largely unemployed.

But Indianapolis couldn't absorb all of them. Many gathered near the poor neighborhoods along the White River and some found work on the Indianapolis to Edinburgh railroad. By the 1860s the Irish had concentrated in the Irish Hill area between Shelby Street and College Avenue, on the east side, and in the Fountain Square area southeast of downtown. Many worked at the Kingan and Company meatpacking plant on the White River. Other Irish helped form the 35th regiment (later consolidated with the 61st). By 1870, the Irish comprised 31 percent of the foreign born and had become a political force within the Democratic Party in the city. They formed churches such as Holy Cross in 1840 (later St. John's) and they opposed the Temperance movement. In the 1860s and 1870s, several mayors were of Irish descent.

German immigrants comprised the largest ethnic group in Indianapolis before the Civil War. As with the Irish, Germans came to central Indiana because of economic conditions and political turmoil in Europe. Also like the Irish, the German immigrants in part came to escape the aftermath of the Napoleonic Wars. They also fled their homeland because of authoritarian rule in the years leading up to the 1848 revolutions. But unlike the Irish, who were mostly Catholic, the Germans were more of a mixture—some Catholic, some Protestant, and even some Jewish. By 1850, people of German ancestry comprised 13 percent of the total city population. Because they were more of a diverse ethnic group than the Irish, they were able to contribute in more diverse ways than the Irish. But they were also less cohesive politically and socially, because of their diversity. Regional and religious differences in Germany were transplanted into their new American homes. But like the Irish, they identified with their churches and clubs. After the 1848 revolutions, those who came here were generally well educated, politically liberal, anti-clerical, and socially progressive. They believed in contributing to their new homeland. They had an active press and established many businesses. They opposed slavery and formed the 32nd regiment in Indiana's Civil War effort.

These early, formative years in Indianapolis saw the development of many institutions vital to the growth of a city, including government, education, organized religion, thriving businesses, the beginnings of a manufacturing base, and a system of transportation that would place Indianapolis at the

center of a hub with roads and railroads radiating out in all directions.

City government for Indianapolis came slowly, due to the fact that the city was created to be the seat of state government. Initially, little thought was given to how the city would govern itself. County government was established at the end of 1821, but county officials did not meet in an official capacity until mid-April, 1822, after the state legislature had met for the first time in the new capital. At that time, the elected officials included a sheriff, a judge, a clerk, a recorder, and three county commissioners. The city was governed by state laws and administered by the county officials.

Through the nineteenth century, Indianapolis passed five town charters. The first town government was formed in February 1832, at which time the city's first charter was adopted. Two thirds of eligible voters within the town petitioned the county commissioners to approve incorporation and to call for elections. A town board was elected with five trustees, each elected to represent one of the city's five wards. Samuel Henderson, an early settler who was later elected the city's first mayor, was chosen as board president. Fire and police protection also was established by the trustees, including a town marshal, and funds for a hand-drawn pumper. The following year a board of health was established after a cholera epidemic hit the city.

Following the Panic of 1837, in which many residents were left destitute, the city began to expand its services to include aid for the poor in the form of a county poorhouse and a Benevolent Society. In February 1838, the city renewed its charter, expanding the town board to six members and expanding jurisdiction to cover the entire four-square-mile federal donation, instead of just the mile square. It established a town council, each member of which was elected annually. The town council could elect other government officials, tax property within the mile square, license and regulate markets, and adopt any laws necessary to maintain the peace.

Finally in February, 1847, the town of Indianapolis incorporated as a city, more than 25 years after its founding. With this election, a mayor was elected to a two-year term, the council was expanded to seven members, boundaries of the city were set, and the council was authorized to elect a secretary, a treasurer, a town marshal, a clerk, and an assessor. A sanitary commission also was established. This charter also authorized a local school tax and expanded the tax base to all lands of the original federal donation. In March, 1853, the charter was renewed and the numbers of councilmen were expanded to two per ward while making the mayor the president of the

council. All elected officials were limited to one-year terms. The council was empowered to appoint city officials, pass ordinances for local governance, maintain and enforce sanitary regulations, annex property, and establish licensing procedures.

The first settlers in Indianapolis brought many traditions with them. Among these were their religious traditions. Although they could not bring their churches with them, they did bring their faith. Religion played an important role in the development of Indianapolis because it provided a moral base for the settlers and a forum for the settlers to gather and discuss the issues affecting them. Although the majority of residents were not affiliated with any formal church in the early years, this was not a reflection of any lack of faith; rather it reflected a lack of organized churches in the city in the early years. Even with the lack of organized churches, the residents were able to practice their faith by gathering in the open, in barns, or in homes to hear the sermons and preaching of itinerant preachers, such as Methodist circuit riders. These preachers would travel from town to town, usually on horseback, preaching to whoever would listen. Also in the early 1820s several cross-denominational organizations were formed that served all who came, including the Indianapolis Bible Society and the Indianapolis Sabbath School Union. By the late 1820s, organized Protestant churches, among them Methodists, Presbyterians, and Baptists, began to hold regular services. Irish and German immigrants, who had come to work on the National Road, and later the Central Canal, established several Catholic parishes.

Early on, it was clear that mainstream Protestantism would be the leading religious force in Indianapolis. The majority were Methodist, Baptist, and Presbyterian. But within a few years, Lutherans, Episcopalians, Quakers, and others also could be found in the city. Methodist circuit riders were probably the first preachers to come to the city and had the largest number of adherents for most of the nineteenth century. The circuit riders regularly visited the city until the late 1820s. From 1825 until 1829, they preached in a log building on Maryland Street, southwest of the Circle. In 1829, the church built a more permanent structure on the southwest corner of the Circle. Baptists also came early to Indianapolis, building their first church just south of the Circle, also on Maryland Street, at about the same time that the Methodists erected their building on the Circle.

In the 1830s, other Protestant denominations organized churches. The Disciples of Christ built their first church in 1836 on Kentucky Avenue,

although they had organized three years earlier. During the 1850s, they established North Western Christian University, which became Butler University in 1877. Lutherans and Episcopalians also established churches in the late 1830s. By mid-century, smaller ethnic congregations gained strength as immigrant populations grew. But they generally were not large enough to exert much influence on the mainstream Protestant developments in Indianapolis.

Another important development in early Indianapolis was the growth of schools. Although slow to develop as a system, the state legislature enacted many laws regarding schools. The first constitution of Indiana, debated in June 1816 by 43 delegates of varied backgrounds, was in many ways a conventional document. It was patterned after the constitutions of the neighboring states of Ohio and Kentucky, and established a Bill of Rights (Article 1), three branches of government (Articles 3 through 5), and a representative government for the state. But in at least one way, the constitution was farsighted. Article 9, Sections 1 through 3, directed the state to provide for the education of its children. Section 1 stated:

> . . . it shall be the duty of the General Assembly to provide, by law, for the improvement of such lands, as are, or hereafter may be granted, by the United States to this state, for the use of schools, and to apply any funds which may be raised from such lands, or from any other quarters to the accomplishment of the grand object for which they are or may be intended.

The article goes on to state further conditions of land sale and the use of sale funds, as well as authorizing the general assembly to enact laws appropriate to the furthering of education in Indiana. Other sections of the article were more specific in establishing the school system. Section 2 stated:

> It shall be the duty of the General Assembly, as soon as circumstances will permit, to provide, by law, for a general system of education, ascending in a regular gradation, from township schools to a state university, wherein tuition shall be gratis, and equally open to all.

Later sections of the article describe how other funds would be gathered and applied to educational needs.

Unfortunately, no funds were allocated for the educational plan and free public schools did not open until 1853, after the second state constitution was enacted. Reasons for this included the Panic of 1837, which limited state funds; inadequate state revenues to fund schools in the state's 900-plus townships; and the collapse of the state's Mammoth Internal Improvements program that essentially bankrupted the state. In the intervening years, however, there were church affiliated schools and basic education was often conducted in the home. There were also private schools for those who could afford them, but their funding was limited and attendance was never high.

The state was not idle, however, in establishing laws that would allow for the growth and structure of a school system. As early as the first legislative session in 1816–1817, the state enacted a law that allowed county commissioners to name a school superintendent for each congressional township. In turn, the superintendent could lease the land in Section 16, the section set aside for education, proceeds of which would go to that township. Homeowners within the township could also petition the county commissioners to call for the election of three township trustees to establish and support schools within that township.

In 1821, the legislature appointed a committee of seven men to establish a plan for the graduated system of free education, up to the university level. In 1824, the legislature passed yet another law that declared that township meetings with at least 20 persons present could elect three trustees to serve as a school board for that township. Proceeds from the sale of land within a township would be at the disposal of these trustees, to be used for schools. Other aspects of this law included dividing up the township into districts, and instructions for the building of schools. Similar legislation continued to be passed in the 1830s and 1840s, further defining how common schools would be constituted and governed. There were several reasons for the continued interest in education by the general assembly, including increased population growth (which meant more tax revenue and more students), and the general improvement in the overall economy (despite the collapse of the Mammoth Internal Improvements Act and the Panic of 1837). There would be further legislation and statewide conventions to discuss the future of a system that was not yet in place. Financial support would continue to be a problem, but finally, after the second state constitution was passed in 1851, the common school system began to operate in 1853.

Among the earliest and most important of the transportation developments that influenced the future growth of Indianapolis was the building of the National Road through the capital city in the 1830s. As the nation's first federally funded east-west transportation project, the National Road had a significant effect on the settlement and development of several states, including Indiana. In 1806, Congress passed legislation to fund the National Road after much debate concerning whether the federal government had the authority to conduct internal improvements. There also was considerable debate concerning what route the road should take because commercial development was sure to take place along it. The road would also mean the founding of many new towns.

But the most important factor in selecting the route for the National Road was that it would open up the states west of the Appalachian Mountains, allowing farmers to send their goods east and manufacturers in the east to send their goods west. And while it would open up the western states, it would also tie the nation together. The selected route began at Cumberland, Maryland, already serving as the intersection of several roads, and would run west to the Mississippi River, across the new states being carved out of the Northwest Territory. Although never completed, the National Road did make it as far as central Illinois, to Vandalia. The first section was built between 1811 and 1818, from Cumberland to the present day Wheeling, West Virginia. It connected the Potomac River to the Ohio River, providing the first link between the nation's capital and the nation's interior.

Jonathan Knight surveyed the route through Indiana in the late 1820s, finding few towns along the route. Between Richmond and Terre Haute, there were essentially no towns, except Indianapolis and a few other, smaller towns. Indianapolis was less than a decade old and had fewer than 1,000 inhabitants, but it was the state capital and the route was planned to run along Washington Street. When the National Road reached Washington Street, it was widened from approximately 80 feet to 120 feet, the same as Washington Street itself. The road was made of broken stone with gravel in the center. A covered toll bridge, built of wood and resting on stone piers, was built across the White River between 1831 and 1834. The first appropriation for Indiana ($51,600) came in 1829, with further funds appropriated each year thereafter. The first contracts were let in 1829 to cut timber, clear stumps, and grade the entire route through Indiana. The last appropriations were made in 1838. With the final

appropriation, the federal government spent over $1 million to construct the road in Indiana.

The development of transportation routes in Indiana, and particularly in Indianapolis, involved several projects that were under construction at the same time. An example of this was the building of the Michigan Road. Planned in the 1820s, the Michigan Road began in Madison, then the largest city in the state, and ran through Versailles, Shelbyville, Indianapolis, and Lafayette, bypassing the marshes of northwestern Indiana, and ending in Michigan City. With the National Road and the Michigan Road bisecting Indianapolis, the capital city became the hub for an ever-expanding system of transportation that made Indianapolis one of the most important cities in the growing Midwest. But these two roads were not the only projects in and around Indianapolis during the 1830s.

The success of the Erie Canal in New York inspired the Indiana General Assembly to pass the Mammoth Internal Improvements Act in 1836. The Central Canal in Indianapolis was one of eight projects authorized by the bill. The other projects included the Whitewater Canal (and a link between it and the Central Canal), the extension of the Wabash and Erie Canal from the mouth of the Tippecanoe River to Terre Haute (connecting the Eel River to the Central Canal), a railroad from Madison to Lafayette (through Columbus and Indianapolis), a macadamized road from New Albany to Vincennes, the study of a route between Jeffersonville and Crawfordsville to determine the practicality of building either a railroad or a macadamized road, the removal of obstructions to navigation in the Wabash River, and a survey for a possible canal or railroad between the Wabash and Erie Canal and Michigan City.

The legislature authorized the borrowing of $10 million to pay for the projects, while the income for the state was less than $100,000. The Central Canal alone was expected to cost over $3 million. The money was borrowed for 25 years at five percent interest. Unfortunately for the state, Indiana's total yearly income never approached the interest payments. This was one of the major reasons the project failed three years later with little to show for it except the completed Whitewater Canal and nine miles of the Central Canal.

The Central Canal was to run from the Wabash and Erie Canal at the Wabash River near Peru, then down along the Mississinewa River, south to Alexandria where it would parallel the White River through Indianapolis, past

Martinsville and Worthington, where it would join the Wabash and Erie Canal down to Evansville.

Prior to the authorization of the Central Canal, the route was surveyed under Jesse Williams, the state canal engineer. The nearly 300-mile route was surveyed by William Goody north of Indianapolis and by Francis Cleveland south of Indianapolis. Within Indianapolis the canal included a feeder dam, an aqueduct, and eight lift locks. Most of the land designated for the Central Canal was already owned by the state. Private property needed for the project was purchased by the state.

Construction began in the fall of 1836 north of the city in present-day Broadripple, which at the time was still outside the mile square. The feeder dam, which controlled the flow of water from the White River to the canal, was earth-filled and measured about 300 feet long by 28 feet high. Construction of the canal itself was made more difficult because the land between Broadripple and Indianapolis was largely uninhabited and heavily forested. The land had to be cleared before the canal could be dug; both tasks were done by hand. The canal was to be about six feet deep and about sixty feet wide. The dirt was used to shore up the banks and form the towpaths, along which horses or mules would pull boats along the canal. By the end of 1838, money had started to run out and construction slowed. By 1839, the canal was essentially complete through Indianapolis and ready for use. The timing was fortuitous because the state was no longer able to make its interest payments and there was no more money to complete the project. Work on the other projects also ceased.

Despite the celebrations at the completion of the Central Canal through Indianapolis, the rest of the route to Evansville was never completed. The portion that was completed did see some use within the city, but it never met expectations as a transportation and cargo artery. A major reason for this was that by the time it was completed, the next step in transportation was already being planned. Railroads had been talked about since the late 1820s. The debate within the legislature that led to the Mammoth Internal Improvements Act included discussion over the role of railroads in Indiana's future. The canal lobby was more powerful in the 1830s and won the debate and the funding. One of the projects called for a railroad to be built between Madison—Indiana's major port city—Indianapolis, and Lafayette. Over $1 million had been allocated for the railroad. By late 1847, the first railroad in Indiana began operating.

Along with developments in governance, education, and transportation, this period also saw the rise of manufacturing. Although largely based on agricultural surplus, it meant that central Indiana farmers no longer lived at subsistence levels, where they consumed much of what they produced. This was not yet industrialization, which would come later in the century with the introduction of new technologies, new materials, and new methods of production and management. But the rise in agriculturally based manufacturing and home industries such as textiles, utensils, hardware, and lumber were necessary steps in creating surpluses and profits to invest and grow the manufacturing base.

Many factors came together to create a manufacturing base in Indianapolis. In 1850, central Indiana was still very much an agricultural state. By the end of the Civil War, a mixture of advancing agricultural practices and the growth of small factories combined with advancements in transportation to create a manufacturing base that would propel central Indiana into the twentieth century as an industrial power. This transformation was underway by 1850 as subsistence farming expanded into commercial farming. With the expansion of the railroad network, surplus products were able to reach markets never before available, especially in the eastern states. Most early manufacturing, such as grist mills and saw mills, was based on agricultural and timber products. These businesses in turn drew other businesses to their locations, initiating town growth. The capital invested was small, as were the profits, but this growth spurred larger attempts at early industrialization.

An example of this was the Indianapolis Steam Mill Company. Incorporated in 1828 by several prominent Indianapolis businessmen, a large saw and grist mill was built along the White River just north of Washington Street. The legislature helped by allowing the company to cut timber on state owned land. The three-story mill began operation in 1831 and processed wood, grain, and wool products. But the mill closed four years later because it could not transport its products to other markets (because of a lack of a transportation network). It often operated at less than 100 percent capacity. It was eventually closed and later burned down.

Also critical to the rise in manufacturing was the rise of the banking industry. Banks became necessary for manufacturing as surpluses in the agricultural economy became marketable. Banks provided the means by which manufacturers built their businesses, markets, and transported their goods. When the first banks opened in the late 1830s and 1840s, banking was very different than today. They were opened by individuals or groups of people who

invested a few thousand dollars each. With little regulation, it was a precarious business venture and many failed. These early banks primarily served the business community and it wasn't until after the Civil War that they began to serve individual customers. There were no bank branches; each one operated independently and stood alone as a business. Among the major banks formed a century and a half ago that exist today are Merchant's National Bank (which opened in 1865 and is now part of National City Bank), Indiana National Bank (which opened in 1863 and is now part of NBD Corporation), and American Fletcher National Bank (which was the first bank in Indianapolis in 1839 and is now part of Bank One Corporation).

THE CIVIL WAR ERA

The 1850s were years of transition in Indiana and Indianapolis. Over the next 30 years, the state and city would change dramatically. In 1850, Indiana was still an agricultural/rural state with few cities. Approximately 95 percent of the people lived on farms. Indianapolis's population was just over 8,000 inhabitants. Madison was the largest city in the state, primarily because it was the state's largest port. The population center of the state was moving north from the southern counties; nearly two-thirds of the population lived in the northern two-thirds of the state. Most people living in Indiana still had southern roots and were less tied to the eastern states. But Indianapolis had a more diverse population, and major changes starting in the 1850s would forever alter the way its residents lived, how and where they worked, and how they traveled. A strong two-party political system would evolve by 1860 that defined state and city politics for decades. New ways of transportation would forever change how commerce and business developed in the state and its capital, and how people traveled from one place to another. Railroads in particular would revolutionize how the city developed and how its products got to market. Railroads not only tied the state together, but established Indianapolis as the hub of a statewide transportation network. Agriculture would undergo change as well, and new technology and new methods of animal husbandry would improve the farmer's productivity and efficiency.

In 1850, life for the average person in Indianapolis had changed for the better since the first generation of settlers. Although no longer a struggle for survival, life in the capital city was not leisurely either. Agriculture was still the dominant force in economic development, but manufacturing had begun to grow as a percentage of economic output. By 1860, Indianapolis's population would more than double from about 8,000 to over 18,000. The majority of those who lived in the city, worked in the city. The remainder of the population lived on small farms throughout the county. Jobs in the city were in stores, businesses, and manufacturing concerns, much the same as today. But there the similarity ended. There is little else to compare urban living today with 150

years ago. The average work week was six days a week, ten to twelve hours per day. Sunday was a day off and most families spent part of that day in church and the rest with relatives. There were no employer benefits, no unions, no minimum wage, no health insurance, no electricity, no refrigeration, no central heating or air conditioning. The average life expectancy was less than 50 years of age. There was no government safety net for those who did not work or for those who were not able to grow their own food. Each family made its own security by working as long as possible and saving as much money as possible. Of course, this depended largely on a worker's health. The longer a worker lived, the longer he could work. On-the-job accidents were common and there was little in the way of medical care for those injured except for setting broken bones or amputating injured limbs. There was little in the way of medication in the modern sense, such as antibiotics. Most medicine on the market did little to relieve pain or cure diseases such as malaria, cholera, dysentery, tuberculosis, or pneumonia. By mid-century, these diseases were not as common as a generation before. But when they occurred, there was little that could be done. Not even aspirin was available until the end of the century. What applied to the worker also applied to his family. Health care was minimal, with only one hospital in the city. Many injuries and illnesses were cared for by family members at home.

Home life was also very different from today. The mid-nineteenth century home likely was a wood-frame house, possibly brick. Few of the adornments found in today's home could be found in a home of 1850. There was no modern plumbing, no televisions, VCRs, radios, refrigerators, or microwaves. Heating came from fireplaces and wood-burning stoves. But while there was no electricity, there was indoor lighting in the form of candles or oil lamps. The family woke with the sun and went to bed earlier than we do today. While the father worked in the city or on the farm, the mother and older children worked at home. The mother or an older girl shopped daily or at least several times per week for perishables such as meat. There was always cleaning and laundry to do, and cooking took much more time than today. There was little in the way of transportation, except for the horse and buggy. Most people walked to work or to shop and people thought little about walking a mile or more to do either.

Because farming was the main work of most people, state government took an interest in productivity and advancements being made in mechanization and animal husbandry. Accordingly, the general assembly created the Indiana State Board of Agriculture in 1851. The board recommended a state fair be

established to bring farmers together to learn about the latest technology and to provide a forum for the exchange of ideas. The fair was to focus on improving agriculture by emphasizing the latest technology such as mechanized farm machinery. The first state fair was held in October, 1852 in present day Military Park, bounded by West and Michigan Streets. For the next several years the fair rotated to different cities such as Lafayette, Fort Wayne, and Terre Haute. In 1860, a 36-acre plot owned by former Mayor Samuel Henderson was purchased to build a permanent, larger fair site. The land was bounded by 19th and 22nd Streets and by Central Avenue and Talbot Street. This plot now lies well within the city but in 1860, it was outside the mile square. By the time the grounds were ready for the next fair, the Civil War broke out and the site was needed first as a training camp for recruits and then as a prison camp for Confederate soldiers and non-commissioned officers. Between 1862 and 1864 the fair returned to Military Park. In 1868, the fair returned to "Henderson's Grove," where it remained until moving to its present site on 38th Street in the early 1890s.

Another important event that occurred in the city during the early 1850s was the second constitutional convention, held in the fall of 1850. The convention was called to revise and update the original 1816 constitution. New issues had emerged, and it was not uncommon for states to revise their original constitutions after a generation or two. Article eight of the original constitution allowed for a poll to be taken every 12 years to see if there was sufficient interest in calling for amending the original constitution. Five polls were conducted between 1823 and 1849, but only in the 1849 poll was there sufficient interest to call for a new constitutional convention. There were several reasons for the public interest. The financial crisis following the collapse of the Mammoth Internal Improvements Act hurt many Hoosiers and the public wanted assurances that the legislature would not repeat the mistake that had brought about the collapse of the program and state finances.

There also was interest in the legislature to hold biennial rather than annual sessions of the legislature, which would help reduce the cost of government. The voters also wanted the state to establish and fund the common school system, which the state's first constitution had called for. With a growing population, the need to teach the state's young was increasing. There also was the issue of what to do with the monopoly of the state-chartered Second State Bank that was set to expire in 1857. And there was the persistent question of what to do with the state's African-American population. Although Indiana

was never a slave state, African Americans were not welcome in Indiana at the time and the state wanted a solution to the problem.

With the voters' approval, the legislature called for the election of delegates on August 6, 1850. There were to be as many delegates as there were House and Senate members combined. On October 7, 1850, the delegates gathered at the State House, where they were sworn in and convention officers were elected. One week later, with the procedures established and 22 committees selected, the convention began. The committees were charged with drawing up new or amended sections of the constitution. As with the 1816 constitutional convention in Corydon, the majority of delegates were born in other states. Only 12 delegates of the 143 attending had been born in Indiana. More than one-third were farmers. The other delegates represented a variety of professions including lawyers, doctors, merchants, manufacturers, and many different trades. The convention met from October 7 through February 10, 1851. The main resolutions passed concerned the reorganization of state government, the role of the state in banking, and a separate amendment that forbid the entry of African Americans and Mulattos into Indiana. The new constitution was to take affect on November 1, 1851, provided that the public voted its approval, which it did on August 4.

But of all the issues that affected the city at mid-century, the most important and far reaching in its consequences was the Civil War. The Civil War was fought over unresolved issues that dated back decades, including slavery and sectionalism. Sectionalism was the debate over whether new states admitted to the Union would be slave holding states or non-slave holding states. By the end of the war these issues were settled, and by the end of Reconstruction in 1877 the nation and Indianapolis were poised to enter a new age of industrialization and urbanization.

Although no battles were fought in Indianapolis and the city was never in danger, the Hoosier capital was affected in several ways and also emerged a changed city. During the War, Indianapolis served as the focal point for the state's war effort. Over 100 of the state's 169 regiments were mustered into service in Indianapolis. More than 20 training camps were located in and around the capital, along with a federal arsenal and a major prison camp, Camp Morton. The residents of Indianapolis rallied behind their soldiers, supporting them with supplies, and welcoming them throughout the war. Life changed for civilians in other ways as well, as shortages and inflation affected their daily lives in ways not experienced before.

Despite the general support of the city's residents, there was dissent in the press and at the statehouse. Indiana politics had always been partisan and volatile, no less so during the war when both Democrats and Republicans tried to use the war effort to advance their own causes. When the Civil War began, the Republicans held the statehouse and most congressional seats. This gave them a power base from which they could conduct the war as they felt necessary. Governor Oliver P. Morton took full advantage of the Republican domination and conducted Indiana's war effort in a manner that showed the state's support for the Union cause. The Democrats were at a distinct disadvantage even before the war began, mainly because of the positions they took on the issues that led to the war, including their support for slavery.

As the war began in April, 1861, Indiana's Republican Party and the state's war effort centered on the dominant personality of Governor Morton. Morton grew up in Centerville, a small town on the National Road east of Indianapolis, before attending Miami University in Ohio. Afterwards he studied law and joined the Wayne County bar in 1847. Morton was a successful railroad attorney before entering politics as a Democrat. By the mid-1850s, he had become disillusioned with his party after the Kansas-Nebraska Act of 1854, which allowed territories to decide for themselves whether they would enter the Union as slave or non-slave states. Morton joined the new Republican Party, which had been formed out of the remnants of the Whig Party, Free Soilers, and disgruntled Democrats. In 1856, he served as a delegate to the Republican National Convention. He also unsuccessfully ran for governor that same year. By 1860 he had joined the ranks of the Radical Republicans and won election as lieutenant governor. When Governor Henry S. Lane left his position to become a U.S. senator, Morton became governor.

When the war began, Morton's main concerns were providing for Hoosier soldiers and keeping Indiana firmly in the Union camp. Because Indiana initially had been settled largely by pioneers with southern roots, there was some concern that Indiana might support the Confederacy. But once hostilities began, the state firmly supported the Union cause. Indiana had always been anti-slavery and Indiana's constitutions had outlawed slavery. But to Governor Morton, it was not a matter of slavery or who was unwelcome in the state, it was a matter of loyalty to the Union. Morton would go to extraordinary lengths to ensure Indiana supported the Union cause and to ensure that Hoosier soldiers had weapons, ammunition, and the other supplies they needed to fight effectively. The needs of the soldiers became a primary issue to Morton when

it was made clear early on that the federal government would not be able to supply Hoosier soldiers with what they needed. Morton also wanted to make sure that Hoosier soldiers were cared for in the field. In 1862, he established the Indiana Sanitary Commission. The sanitary commission issued supplies to soldiers in the field and arranged transport for soldiers coming home. Along with the sanitary commission, Morton established the Soldiers Home in Indianapolis to care for wounded soldiers. A Ladies Home also was established in Indianapolis in 1863 to aid soldier's families. These actions were of concern to federal authorities as well as to state officials, who feared that Morton was exceeding his authority as governor.

During the summer of 1862, an incident south of Indianapolis momentarily struck fear into the hearts of Hoosiers as the war was suddenly brought closer to home. Confederate General John Hunt Morgan and about 2,500 cavalrymen crossed the Ohio River on July 8 and raided Corydon and Salem. Governor Morton called for militia aid and for citizens to take up arms to protect the city. It was feared that Morgan would raid the federal arsenal and try to free Confederate prisoners held at Camp Morton on the north side of the city. But instead of continuing north, Morgan turned east from Salem and crossed into Ohio. Indianapolis heard the news on July 14. Ironically, more than a thousand of Morgan's raiders were captured in Ohio and later transferred to Camp Morton.

In the election of 1862, Morton was more challenged by the Democrats than he probably anticipated. The war itself favored the Confederacy, despite the overwhelming resources of the North. The casualty lists, nationally and in Indiana, were growing, and dissent was surfacing. By the time of the election, Lincoln had already issued the preliminary Emancipation Proclamation. Indiana did not support the institution of slavery, but the 1851 constitution did not allow African Americans into the state. Democrats counted on the anti–African American sentiment and the "twin specters of abolition and Negro equality." The Democrats hoped to exploit this fear of African-American entry into Indiana.

The Democrats won the election that October, capturing both houses of the general assembly and winning seven of eleven congressional seats. After naming Thomas Hendricks and David Turpie to the U.S. Senate, the Democrats attempted to strip Governor Morton of much of his power. To prevent this, the Republican contingent in the general assembly left Indianapolis, at which point the legislature ceased to function. Governor Morton took the reins

of government himself and ran it for the remainder of the war. His actions confirmed what the Democrats had always accused Morton of—attempting to rule the state himself and conduct the war as he saw fit. But the Democrats also complained about Republican conscription policies, tariff policies, press restraints, and the suppression of local to national authority.

Morton, on the other hand, was in a position to continue his attack against the Democrats. During and after the war, the Republicans waved "the bloody shirt" against the Democrats, accusing them of supporting and collaborating with the South and with being pro-slavery. Morton never conceded that he overextended his authority. Instead he pressed his attacks on the Democrats, specifically accusing them of being part of the Sons of Liberty, a nebulous group supposedly plotting to take over the state and removing it from the Union.

In the spring of 1863, Morton learned of a plot by the Sons of Liberty to take over state government during the Democrat State Convention. Guards were posted at the convention site to intimidate those attending. When the meeting adjourned, soldiers followed some of the attendees to the train station. After shots were apparently fired, soldiers boarded the departing train and confiscated numerous weapons. Some of the passengers managed to keep their weapons long enough to throw them out the train windows into Pogue's Run, after the train left the station. So ended the Battle of Pogue's Run on May 20, 1863.

Perhaps the most important event concerning Indianapolis during the war was the Milligan case. Lampdin P. Milligan was a Huntington lawyer and moderate Democrat who had tried to gain the Democratic nomination for governor in 1864. Shortly before the election, Milligan and several others were arrested and charged with treason. The trial was held in November and three of the four tried, including Milligan, were sentenced to be hanged. The executions were scheduled for the following spring, pending an appeal. In a landmark case for civil liberties, the U.S. Supreme Court ruled that as long as civil courts were operating, military tribunals of civilians were illegal. Whatever role Governor Morton played in the arrest is unknown, but he was reelected by a wide margin that October and the Republicans won control of both houses of the general assembly along with eight of eleven congressional seats. President Lincoln also won reelection. Republican control of the state would continue until the end of the war.

News of the end of the war in the spring of 1865 was met with jubilation and celebration in Indianapolis. It had been a titanic effort on the part of the

state, and Indiana's contributions were significant. Over 200,000 Hoosiers had served in the war in 129 infantry regiments, 13 cavalry regiments, and 26 artillery batteries. Thirty nine regiments had Indianapolis and Marion County representatives. Hoosiers fought in both east and west theaters. In all, more than 25,000 Hoosiers died, most from disease, but more than 7,000 from war-related wounds.

Another important Indianapolis contribution to the state's war effort was Camp Morton, the former state fair grounds and training camp that was converted into a Confederate prison camp for enlisted men and non-commissioned officers.

Within five days of the start of the war, the first troops to train in the camp arrived. Modifications made to the grounds during April allowed for the camp to hold up to 6,000 soldiers. Despite the problems of properly housing, feeding, and clothing the soldiers, the camp served its purpose for the first year of the war. But by February of 1862, the federal government needed sites to house the growing numbers of Confederate prisoners, and Camp Morton was selected as one of eight new Northern prison camps. There were some officers in the first trainloads of prisoners, but since Camp Morton was designated for non-commissioned officers and enlisted men, they were eventually transferred to Massachusetts and Ohio. The number of prisoners quickly rose, and by the summer of 1862 over 4,000 prisoners were held at Camp Morton. While the numbers fluctuated over the next three years, due largely to transfers and exchanges, the camp often housed several thousand prisoners.

Living conditions at the camp were better during the first year of operation, under the enlightened leadership of Colonel Richard Owen. But this is not to say that conditions were ever good. Diseases such as malaria, dysentery, and pneumonia were common. A lack of blankets and heat in winter were consistent problems. The food, while adequate at first, declined in both amount and nutritional value over the three years of operation.

The first prisoners arrived on several trains in late February, 1862, and consisted of over 3,000 officers and enlisted men. Although the camp was ready for prisoners, dealing with clothing, feeding, and housing that many men at one time was a daunting task. Commandant Owen laid down a series of laws dealing with conduct of the prisoners and guards. For the most part, the prisoners were allowed to rule themselves, as long as there were no violations of the rules. Owen made some attempts to improve conditions during his months at the camp. A bake house was added, for example. During the winter months extra

blankets had to be provided by the sanitary commission and the Ladies Patriotic Society. For a time prisoners had their own money, and recreational activities were allowed in the central, open area. Discipline was never a major problem, but fights, arguments, and escapes did occur. These increased when Owens's successor, Colonel David Rose, took over in the summer of 1862. During his time conditions deteriorated, partly because he had a harsher view of how to treat prisoners and partly because shortages of food and clothing grew worse over time. Even the citizens of Indianapolis, who had contributed food and clothing early on, eventually lost interest in the novelty of having a prison camp just outside the city limits. The third commandant, Ambrose Stevens, was able to improve conditions somewhat, but conditions never returned to the level of when Richard Owen had been commandant. Within two months of the end of the war, all of the prisoners were released. For the three-plus years the camp was in operation, the highest number of prisoners had been nearly 5,000. Death by disease took the greatest toll.

Indianapolis became the state's most important city during the Civil War and during the decade of the 1860s, a decade of transformation. Its central location was a key to this because it served both as the legislative center of the state's war effort and as a gathering point for the soldiers leaving for war and returning home. But central location alone was not enough. The city needed a method by which its location could best serve the state in time of war, and later in time of peace. What made Indianapolis important in the Union war effort besides its central location was its growing railroad system. Between 1850 and 1860 Indiana's railroad mileage increased by a factor of ten, from 200 miles to over 2,000 miles, and much of this growing network centered in Indianapolis. Not only did it allow troops and supplies to move more quickly and efficiently to the battlefield, but after the war, those same rail lines allowed the city to serve the entire state by moving products, raw materials, and people to virtually every corner of the state. Not only did railroads tie the state together, but they also allowed the city to expand outward into the rural areas of Marion County and beyond.

Railroads were relatively new to the capital city, the first reaching the city from Madison on October 1, 1847. Fifteen years earlier, the state had chartered eight rail lines, five of which would run through Indianapolis. Two of these were funded by the Mammoth Internal Improvements act of 1836, the Madison, Indianapolis, and Lafayette line, and the Lawrenceburg and Indianapolis line. The renamed Madison and Indianapolis line (the M & I)

was the first to reach Indianapolis. Construction of the 87-mile long track was difficult and fraught with financial problems, as were all the projects of the 1836 legislation. But the line operated successfully for several years, hauling agricultural products to southern ports and manufactured products to the capital city. Competition from other railroads caused the eventual decline of the Madison and Indianapolis rail line, but parts of it are still in use today. With the success of the M & I, others were soon built and by 1855, there were seven more lines serving Indianapolis: the Peru and Indianapolis (to Noblesville), the Lafayette and Indianapolis, the Lawrenceburg and Upper Mississippi (connecting to Cincinnati), the Terre Haute and Richmond, the Jeffersonville, the Bellefontaine (to Union City), and the Indiana Central (to Richmond).

While these lines tied much of the state to Indianapolis, they also tied Indiana to other states, bringing the Midwest together into an economic unit that would serve as an engine for industrial development in the coming decades. For Indianapolis and Indiana as a whole, this network created markets for Indiana's agricultural and timber products, and later, for Indiana's industrial products. In return, manufactured products from other parts of the nation more easily came to central Indiana.

As competition grew, those lines that operated inefficiently or under financial pressure were absorbed into larger systems financed from the East Coast. Several of the initial lines serving Indianapolis were absorbed into the Pennsylvania, New York Central, and Baltimore and Ohio systems.

Closely tied to the expansion of the railroad network was the rise of manufacturing in Indianapolis and throughout Indiana in the decade after the Civil War. There had been manufacturing on a small scale for decades, rooted largely in home industries such as food processing, textiles, farming implements, and furniture making. But a number of factors had to come together before manufacturing became a major economic force. Railroads were an impetus for this growth by providing a means to carry more products further and faster to both traditional and new markets. This was particularly important for perishable products. At the same time railroads provided a means to carry new products into Indiana as well as the raw materials needed to fuel the growth in manufacturing. Indianapolis served as the focal point for this expanding railroad traffic, especially after the Civil War when concentration was shifted away from war toward economic development.

The rise of manufacturing was not an overnight process. It took decades. And while the railroads provided the means for growth, the Civil War proved

to be another important factor because it focused the growth of railroads toward the capital city. Most troops that traveled by rail came into and left Indianapolis. The same was true of the supplies they needed. There were other factors in the rise of manufacturing. Along with transportation advances and the rise of manufacturing, these factors propelled Indiana into the age of industry and industrialized agriculture.

Already by 1850 commerce and manufacturing were increasing. Farmers wanted to expand beyond mere subsistence into commercial farming. This became possible as the population grew larger and moved north into new farmland. The southern markets would no longer be the focus of Indiana's agriculture because the eastern markets had larger populations with better transportation networks.

Other sectors of the economy also became involved. Among these were the bankers who financed the growth in production, the manufacturers who made the products, and the merchants who provided the markets. Initially these were based on the agricultural economy. The small, individually-owned shops or mills were the first steps because they acted as the initial producers and markets. Profits spurred continued growth.

During the early nineteenth century, agriculture was the dominant economic force in Indiana and whatever manufacturing existed depended largely on agriculture and timber. The leading industries were meat products, flower and meal, timber, and liquor products. Most of these were concentrated in the southern, more populated regions of the state because they were closer to the port cities. Poor transportation to the interior of the state also kept manufacturing away from central Indiana. Crafts and trades flourished, as did mills of various kinds. Few factories existed beyond the small shops. The development of skilled crafts and trades encouraged a division of labor as special skills were developed. Urban centers in particular attracted a greater diversity of workmen who preferred skilled jobs and trades to a rural life. As transportation developed, these trades and skilled jobs moved north with the population. Although Indianapolis was the capital city, it was still very much a rural community until the coming of the railroads. Those not engaged in farming were likely employed in food or lumber processing. The abundant timber resources also encouraged a growing craft economy in Indianapolis, but Indianapolis needed more than forests and farms to create the growth expected of a capital city. It needed the railroads to create the hub of transportation needed to develop further.

INDIANAPOLIS

In 1847, when the first railroad came to Indianapolis, the population was about 5,000, spread over the one-square-mile city. Most of the people lived on farms and largely practiced subsistence farming with some surplus. What surplus existed was used in the trades and crafts. There were about 100 business establishments.

Once the railroad network was expanded to Indianapolis, commercial transportation became more common. Manufactured goods were cheaper and more readily available. Both import and export costs were reduced, which created more surplus wealth. This surplus changed the Indianapolis economy forever. The manufacture of goods, albeit still largely agricultural, went beyond local consumption. Like other cities located near arteries of transportation, Indianapolis became a trans-shipment point to other cities further in the interior of the Midwest. Indianapolis became an important link in an ever-growing network.

Three examples of the rise of manufacturing in Indianapolis are the stories of Kingan and Company, L.S. Ayres and Company, and Eli Lilly and Company. Two of them have thrived for well over a century. The third, Kingan and Company, lasted just over a century. All three are examples of how well-run, productive companies survive changes in the economic fortunes of a city.

Samuel Kingan, along with his two brothers, Thomas and John, opened their first meat-packing plant in Belfast, Ireland, in 1845. The firm prospered selling pork products to the British Navy. The 1840s were a decade of famine in Ireland and Kingan's plant was pressured to increase its supplies to British markets in order to fill the gap left by the potato famine. In 1851, the firm opened a plant in Brooklyn, New York. Two years later, they opened another plant in Cincinnati, Ohio, long known as a major meat-packing center. In 1862, after both plants burned down, the Kingan brothers opened a third American plant in Indianapolis.

Kingan and Company was not the first meat-packing plant in Indianapolis. As early as 1835, James Bradley opened a plant along White River. Other plants opened during the 1840s and 1850s, but they were all small operations. Within a few years after Kingan's opened in Indianapolis, it was one of the largest meat-packing plants in the world and would remain one of the largest for decades. The plant was located on two sites along White River, just south of Washington Street. Originally it operated on a 10-acre site on the west side of the White River, on the current site of the Indianapolis Zoo, but later added another 16 acres on the east side of the river where Victory Field is now

located. The original building had six floors and totaled about 130,000 square feet. At its peak, it could process 3,000 hogs per day.

Pork packing was not a new industry. Both salting and smoking of pork dated back decades and products such as ham, bacon, and sausage had been staples since colonial times. Hogs also were easier to care for than cattle, as they were usually allowed to roam freely until winter when they were penned, fattened for a few weeks, and slaughtered. Hogs also had a much shorter gestation period, making them a more profitable commodity than cattle. The major shortcoming of the hog industry was that it was seasonal. Slaughtering and packing had to take place during winter, to prevent spoilage.

Around 1870, this problem was remedied when refrigeration was introduced at the Indianapolis plant. It was a relatively simple process. Ice blocks from local sites were procured and installed on the top floor of the six-floor facility. Since cold air descends, a series of pipes was installed to draw the cold air to the lower floors where the slaughtering and packing took place. This allowed a longer packing season, which meant that more hogs could be processed over a longer period of time. With the expansion of the railroad network and the introduction of refrigerated cars, pork packing became a year-round industry.

Other innovations at the Kingan facility included a conveyor system to move hogs more effectively along the production line, a hog de-hairing device, a canning process to prevent spoilage, and the packaging of sliced bacon. But perhaps the most important of Kingan's innovations was its hiring practices. Throughout much of its 100-plus years of operation, Kingan's hired Irish and other immigrants. It was not unusual for Irish immigrants to ship their personal belongings from Ireland directly to the Indianapolis facility, even if they had no other address. For generations, thousands of Irish immigrants could count on steady employment at Kingan's. It was not unusual for grandfather, father, and son to spend their entire working lives at the same plant. Not only did Kingan's provide steady work, but also built housing for some of its employees, and a church for those who wished to attend. The company also regularly held social events for its employees.

L.S. Ayres and Company was the first modern department store in Indianapolis. In 1872, Lyman S. Ayres bought a controlling interest in the Trade Palace, a dry goods store just west of Meridian Street on Washington Street. Ayres lived in New York until he moved his family to Indianapolis in 1874 to take personal control of the store. In 1875, he moved the store to a new, larger, three-story building. Customer service was always important

to Ayres and from the beginning he implemented services to enhance the customer experience. Early amenities included electric lighting, telephones, glass display cases, and the first elevator in a retail store in Indianapolis.

Ayres died in 1896 and his son Frederick took control of the company and moved it to its present location on the corner of Meridian and Washington streets in 1905. The new eight-story building was built as a modern department store with specific departments and services on each floor. The basement held economy products. The first and second floors held a variety of personal care products. The third floor carried ready-made men's, women's, and children's clothing; much of it made by Ayres workers. Interior decorations were located on the fourth floor. On the fifth floor was the elegant Tea Room, a restaurant seating 300 patrons. Ayres dressmakers were located on the sixth floor, while carpenters built display cases, cabinets, and upholstered furniture on the seventh floor. The eighth floor was reserved for marketing, shipping, and receiving.

Ayres was not only known for retail and marketing innovations, but also for the way he treated his customers and employees. Like Kingan and Company, generations of people worked at the downtown Ayres store. L.S. Ayres and Company was one of the first companies to provide its employees with vacations, insurance, and bonuses. In-store training programs kept employees up to date on the latest products, fashions, and selling techniques.

Another example of a major manufacturing firm that started in Indianapolis in the 1870s is Eli Lilly and Company. Founded in 1876 by Colonel Eli Lilly, the company grew to become one of the largest and most innovative pharmaceutical firms in the world. Lilly moved to Indiana when he was 14 years old. Two years later he began working as an apprentice at a small drug store in Lafayette and several years later he returned to Greencastle and opened his own drug store. Shortly afterward, the Civil War started and Lilly immediately enlisted. He served with the 18th Indiana Light Artillery Battery and the 9th Indiana Cavalry, eventually returning to Indianapolis in 1876 to open his own drug store. Lilly had seen the rise of patent medicines and elixirs that frequently caused more harm than good, and knew that there was a growing market for quality drugs for the medical profession. He opened his business with $1,300 and three workers, including his son Josiah Kirby Lilly. In the beginning, Lilly's workers produced the drugs themselves. After four successful years, Lilly incorporated with five stockholders. In 1881, he relocated to the grounds just south of downtown, where the headquarters of the company are still

located today. By the time Lilly died in 1898, he was a wealthy man and his business was thriving. His son J.K. Lilly had taken over and, like his father, continued to run the company with an eye toward manufacturing quality drugs for the medical profession. His two sons, J.K. Jr. and Eli, would continue to run the company through much of the twentieth century. Like Kingan and Company and L.S. Ayres and Company, Lilly's earned a reputation for taking care of its employees, producing innovative products, and participating in the civil life of the city that had given it its start.

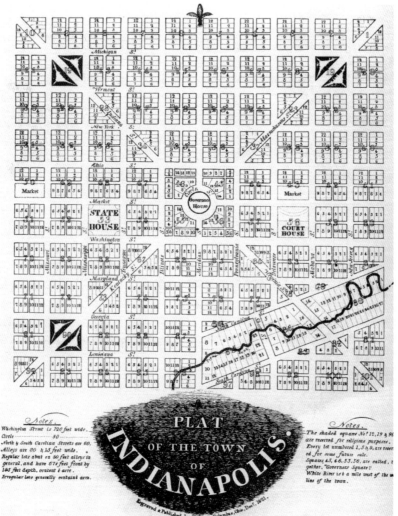

Drawn by Alexander Ralston and Elias P. Fordham, The Ralston Plat called for the new Indiana capital to be one mile square with diagonal avenues radiating out from a central circle. The plat was similar to the one drawn for Washington D.C., on which Ralston assisted.

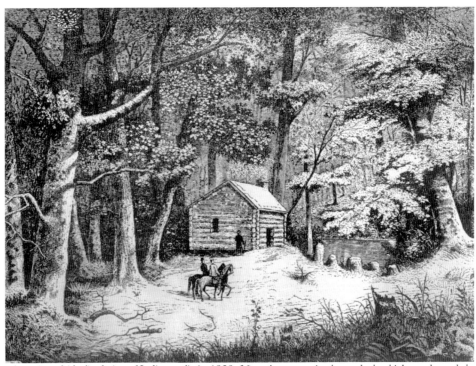

A rustic and idealized view of Indianapolis in 1820. Note the stumps in the road, the thick woods, and the White River in the background.

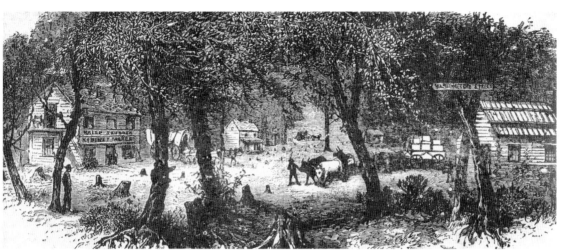

The arrival of the state archives (and presumably other official state papers) to the new Indiana state capital in November 1824. Note the stumps in the roads and the woods surrounding the settlement.

This building in Corydon, Indiana (Harrison County), was the territorial capital from 1813 to 1816, when Indiana became a state. Corydon also served as the first state capital from 1816 until 1825.

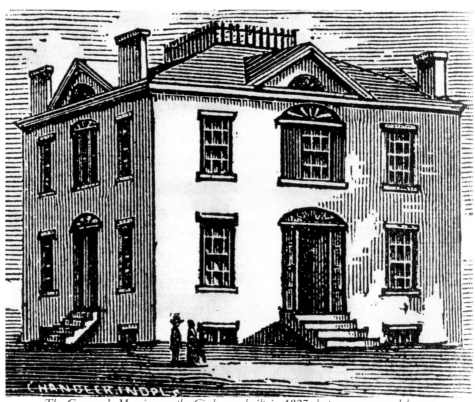

The Governor's Mansion on the Circle was built in 1827, but was never used by any governor. Though used for other purposes over the years, the building fell into disrepair and was torn town in the late 1850s.

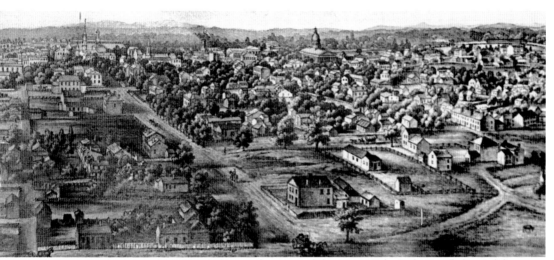

Indianapolis as it appeared in 1854, looking southwest toward the state capital. At the time, Indianapolis's population was only about 10,000. Note that there are no paved streets.

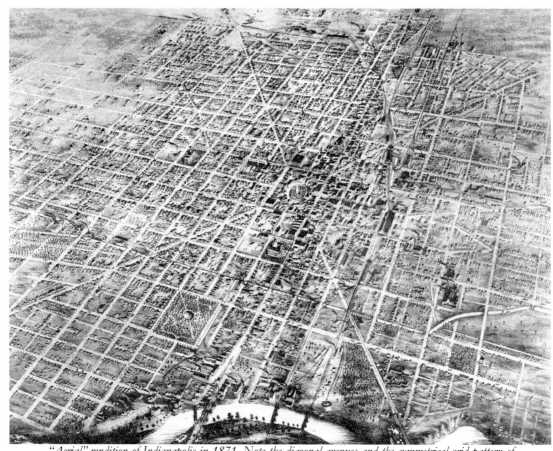

"Aerial" rendition of Indianapolis in 1871. Note the diagonal avenues and the symmetrical grid pattern of the city. The view is looking northeast, with the White River at bottom.

Indianapolis's first state capital, opened in 1835 and torn down in 1877 to make way for the present, larger capital building. Both buildings were located on the same ground, between Ohio Street on the north and Washington Street on the south.

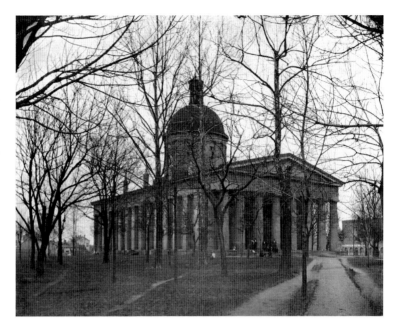

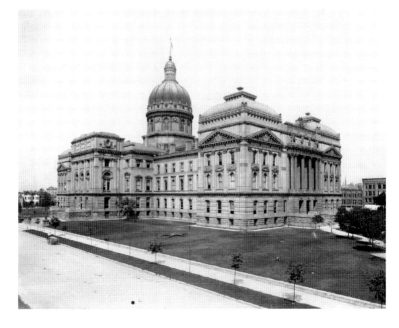

Indianapolis's second and present state capital building opened in 1888. This view is from the west side of the building, facing the White River.

The Indiana State Soldier's and Sailor's Monument and downtown Indianapolis C. *1945, looking northwest.*

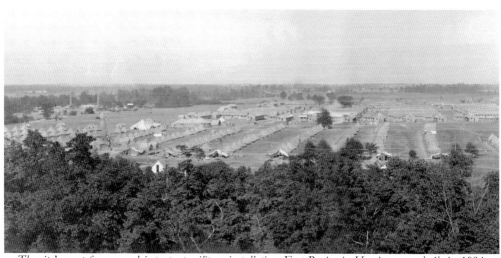

The city's most famous and important military installation, Fort Benjamin Harrison, was built in 1904 as part of the buildup of the American military following the Spanish-American War. This view was photographed in 1917.

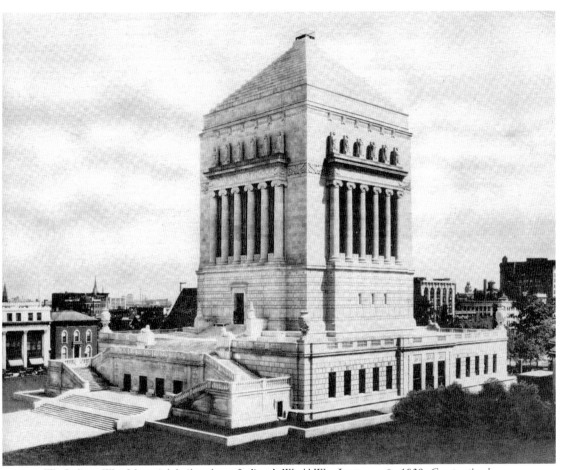

The Indiana War Memorial, built to honor Indiana's World War I veterans, c. 1930. Construction began in 1926, but the interior was not completed until 1965.

World War I "Victory Garden," date and location unknown. Victory gardens were common during World War I to help reduce the amount of food bought during the war. More than 70,000 gardens were planted.

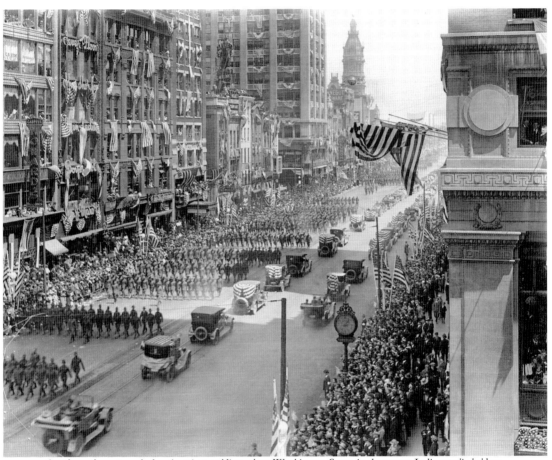

A welcome home parade for American soldiers along Washington Street in downtown Indianapolis held on May 7, 1919. Parades were just one way that local residents showed support for American troops fighting in Europe.

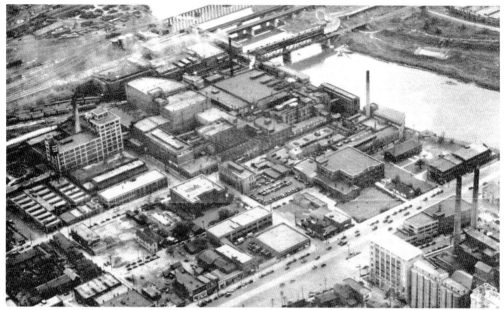

Kingan's and Company, **C.** *1940. Kingan's meat packing company was founded during the Civil War and quickly became one of the largest meat-packing plants in the world. Located on the White River near the present sites of Victory Field and the Indianapolis Zoo, Kingan's employed thousands of Irish immigrants over its century of operation.*

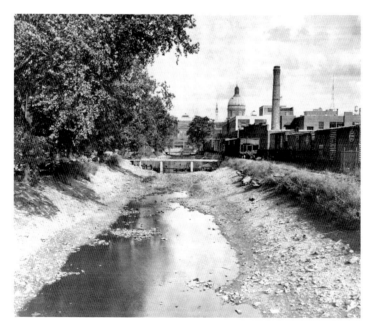

The Central Canal as it appeared in 1951, looking east toward downtown. The site has been rebuilt and the canal is now filled with water. This view is the approximate location of the new Indiana State Museum, which opened in May 2002.

The U.S. Army Finance Center at Fort Benjamin Harrison. Covering 14 acres, this is the largest Army building ever built. The Finance Center has had several name changes since it was built in the early 1950s, when it employed more than 6,000 workers. Although the fort was officially closed in the 1990s, the Army still maintains some of its financial operations at the Finance Center.

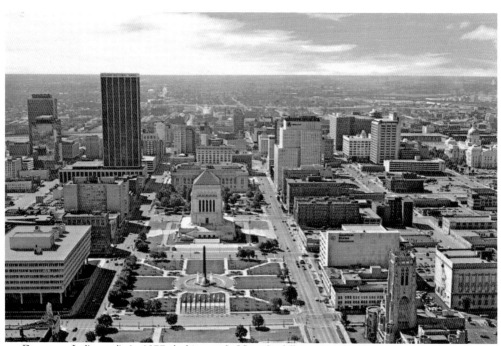

Downtown Indianapolis in 1977, looking south. Note the differences in the appearance of the skyline from the earlier photo of downtown. During the 1980s and 1990s, downtown Indianapolis would undergo another makeover as new buildings and sports arenas were built.

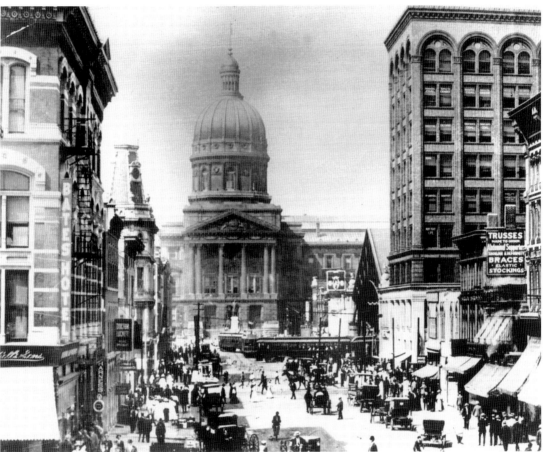

The Traction Terminal and shed on Market Street, looking west toward the state capital C. *1915. The Traction Terminal was built in 1904 to house and centralize the state's growing interurban system. At its height, it operated 400 cars per day on nine tracks. The shed was torn town in 1968 and the adjoining building was razed in 1972.*

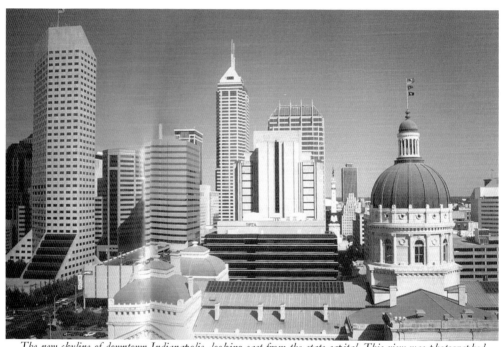

The new skyline of downtown Indianapolis, looking east from the state capital. This view was photographed
C. *2000. Most of the taller buildings have been built since 1980.*

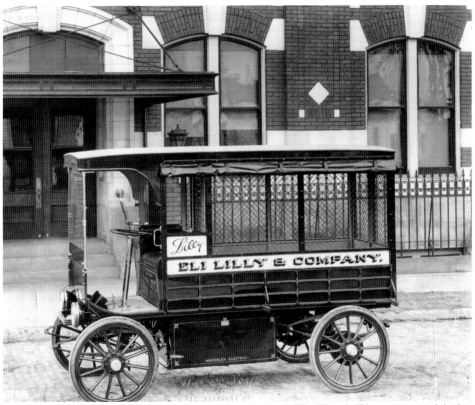

A Waverly delivery vehicle for Eli Lilly and Company, **C.** *1915. The Waverly Electric was one of the first cars built in Indianapolis, and the first electric car.*

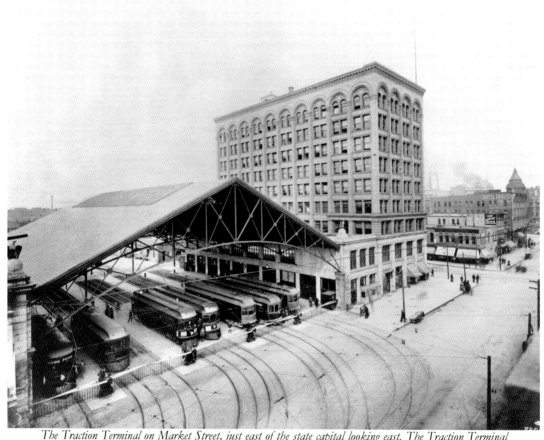

The Traction Terminal on Market Street, just east of the state capital looking east. The Traction Terminal was built to help ease the traffic congestion in downtown Indianapolis and to centralize the burgeoning interurban system in Indiana.

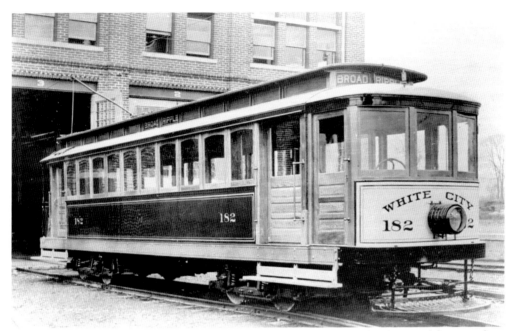

Broadripple interurban car C. 1915. Interurbans helped tie the city together after the turn of the century by providing inexpensive and efficient travel to and from the downtown area.

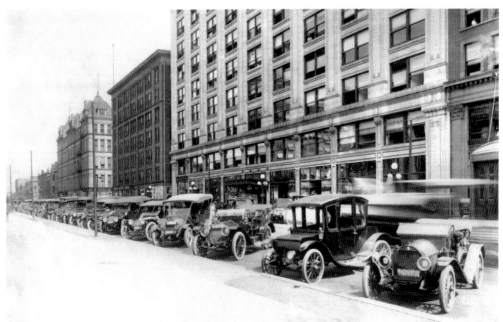

Cars parked on Ohio Street in front of the Federal Building in 1914. Once people began to buy cars, the traffic congestion in the city got progressively worse. Until the advent of parking meters and one-way streets, the problems of congestion continued.

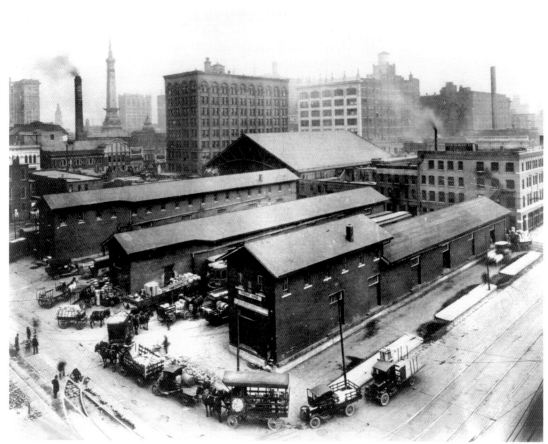

Delivery trucks entering the Traction Terminal from the west and north **C.** *1925. The view is looking southeast. Monument Circle is in the background. Note the smog in the air.*

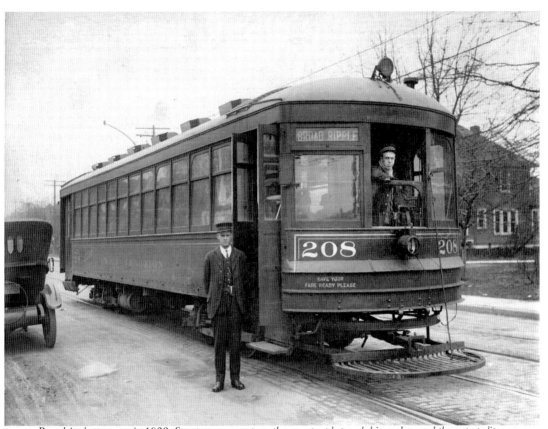

Broadripple street car in 1928. Street cars were yet another way people traveled in and around the metropolitan area. Street cars, interurbans, cars, trucks, and trains all contributed to the congestion of the growing city after the turn of the century.

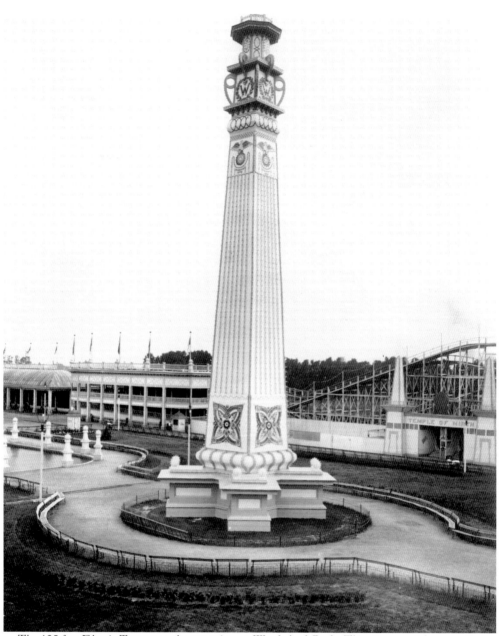

The 125-foot Electric Tower was the centerpiece at Wonderland Park. This view was taken sometime before the park burned down in 1911. Wonderland Park was located on Indianapolis's east side at East Washington and Gray Streets. One of many parks in Indianapolis, it was a symbol of how people in the early twentieth century spent some of their leisure time.

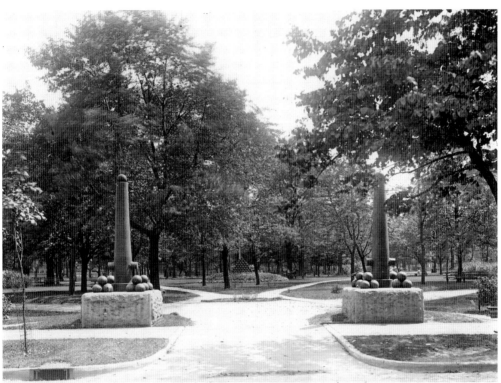

The city's oldest park, Military Park, dates back to the founding of the city. Used as a training ground during the Civil War, it was also the site for several Indiana State Fairs during the 1850s. The park is now part of the re-development of downtown's west side called White River State Park, which also includes the Indianapolis Zoo, the Indiana State Museum, Victory Field, the RCA Dome, and the Eiteljorg Museum of American Indians and Western Art.

Boating on Riverside Park **C.** *1910. Located on west 30th Street at White River, the park was one of the most popular in the city. Riverside Park was severely flooded during the 1913 flood and closed in 1970 after years of neglect, but still houses one of the city's most popular golf courses.*

The Sunken Gardens at Garfield Park, the city's oldest public park. Located about three miles southeast of the Circle, the 128-acre park was established in 1874. The 10,000 square-foot conservatory houses the nation's first welded glass and aluminum roof.

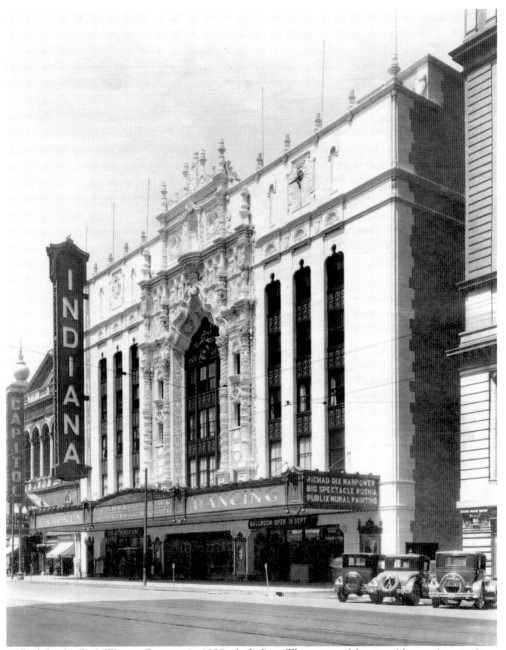

Built by the Circle Theater Company in 1927, the Indiana Theater was elaborate, with a seating capacity of 3,000. Located on West Washington Street, the theater has housed the Indiana Repertory Theater since 1980.

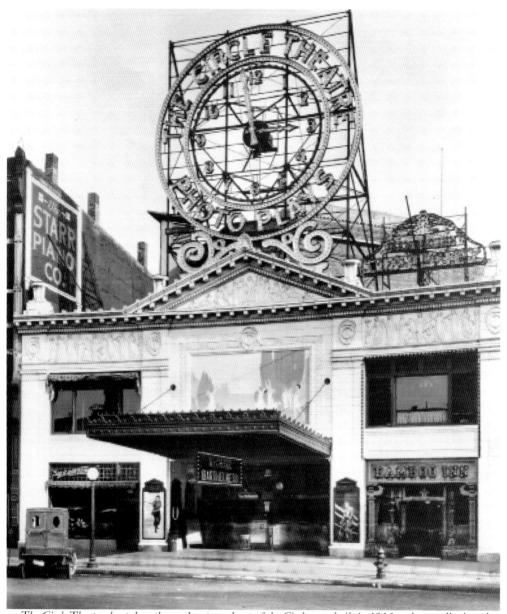

The Circle Theater, located on the southeast quadrant of the Circle, was built in 1916 and reputedly showed the first sound movie in Indianapolis. Extensively renovated, the Circle Theater has housed the Indianapolis Symphony Orchestra since 1984.

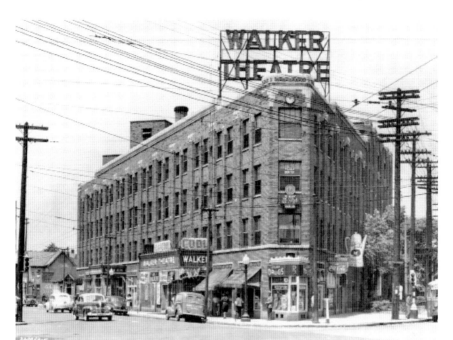

Built by millionaire entrepreneur Madame C.J. Walker in 1928, the Walker Theater on Indiana Avenue hosted movies, jazz concerts, and Vaudeville acts. The building was closed in 1978, but was renovated and re-opened in 1988. This view is **C.** 1935.

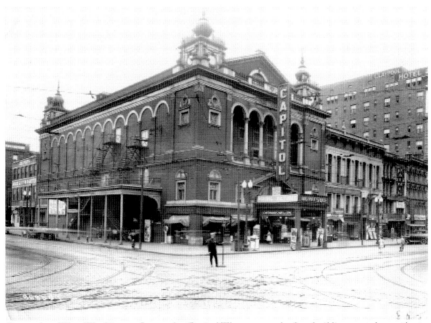

Located on West Washington Street, the Capitol Theater was the first building erected as a theater when it opened in 1858. Originally named the Metropolitan Theater, the name was later changed to the Park Theater, the Lyceum, the Strand, and finally the Capitol in 1923. The building was closed in 1935. This view is **C.** 1925.

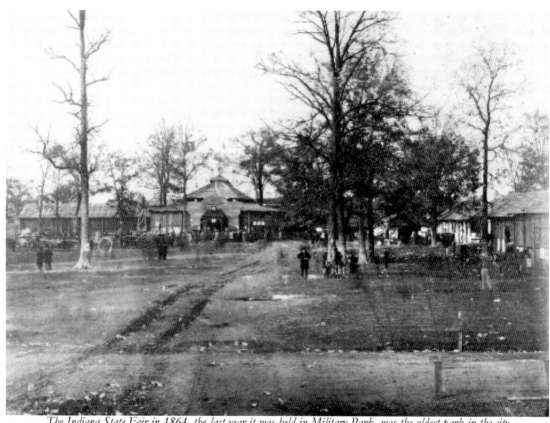

The Indiana State Fair in 1864, the last year it was held in Military Park, was the oldest park in the city. The fair would have been held on its new grounds, called Otis Grove, but that land was converted into Camp Morton after the outbreak of the Civil War.

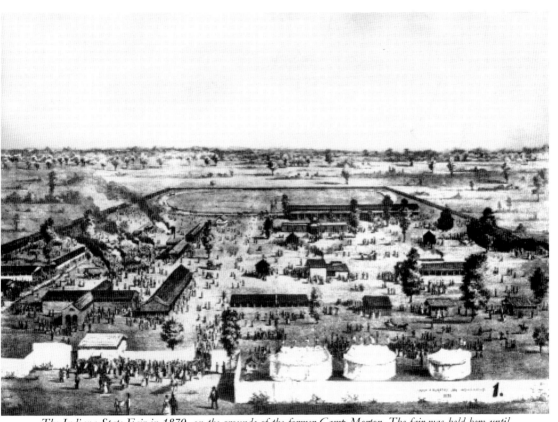

The Indiana State Fair in 1870, on the grounds of the former Camp Morton. The fair was held here until 1892, when it moved to its present location on east 38th Street and Fall Creek Parkway. This view is looking north.

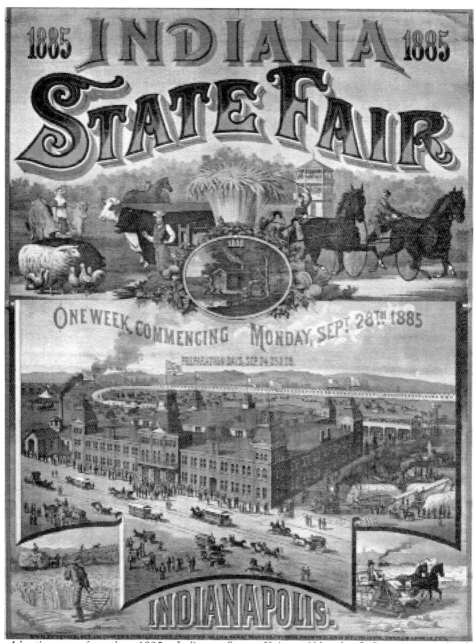

Advertisement for the 1885 Indiana State Fair. Although Indiana was already taking advantage of the new, mechanized agriculture, the images here show little of the new methods. Instead, they picture the more traditional methods Hoosiers had used for generations.

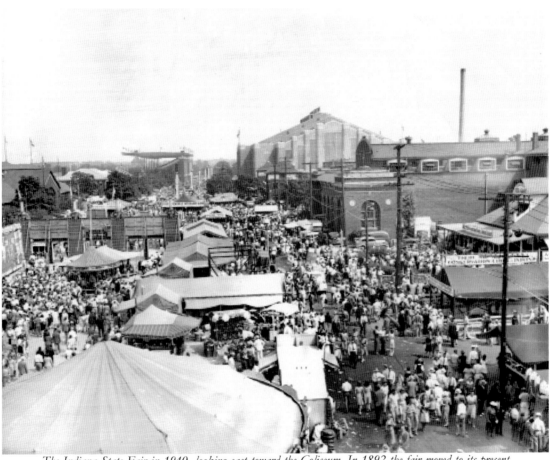

The Indiana State Fair in 1940, looking east toward the Coliseum. In 1892 the fair moved to its present location on east 38th Street and Fall Creek Parkway. Note the immense crowd, not unusual for a typical day at the fair.

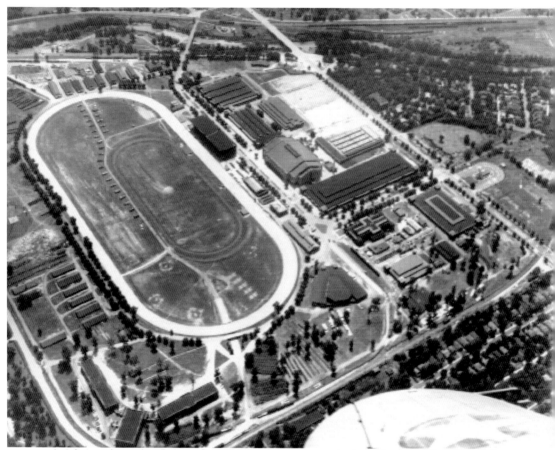

Aerial view of a modern Indiana State Fair, including the race track on the north side. The fair draws hundreds of thousands of visitors each year to its many attractions, such as the Midway and its many exhibition halls. During the rest of the year, the grounds host many trade shows that draw thousands more.

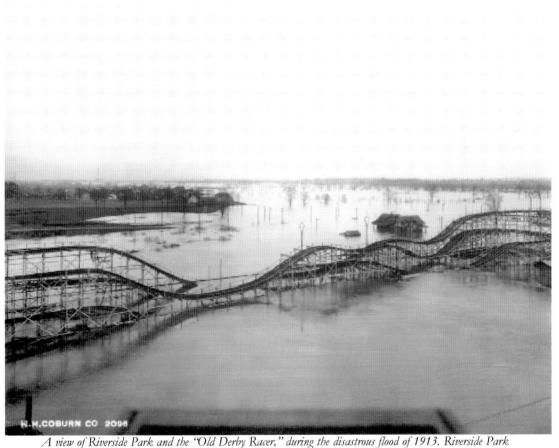

A view of Riverside Park and the "Old Derby Racer," during the disastrous flood of 1913. Riverside Park lies next to the White River, which overflowed its banks throughout the city causing millions of dollars in damage. Some areas were under as much as 30 feet of water.

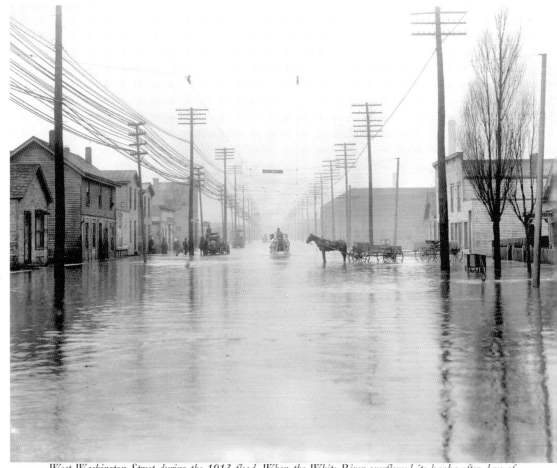

West Washington Street during the 1913 flood. When the White River overflowed its banks after days of heavy rain, homes, businesses, bridges, and roads were destroyed. The west side of Indianapolis was under water for days afterward.

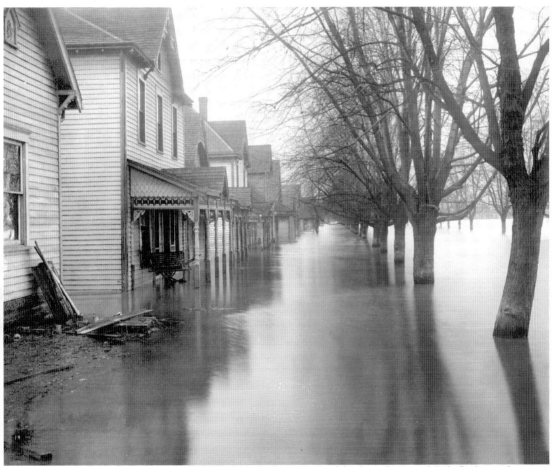

Harding Street during the flood of 1913. The flooding was caused by days of rain and little flood control. Thousands were left homeless and dozens died. After the flood, the federal and state governments began a program to build levees, floodwalls, and pumping stations.

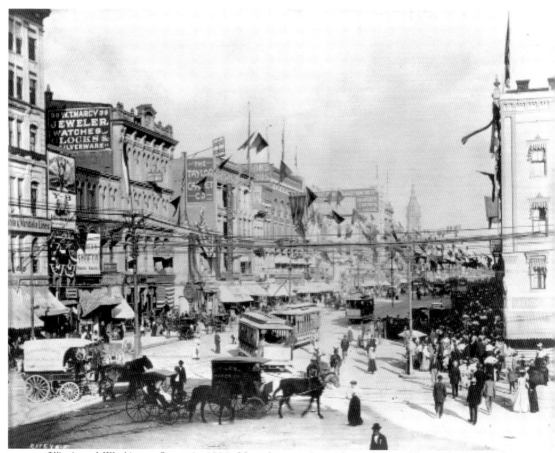

Illinois and Washington Streets in 1901. Note the congestion with a mixture of foot and vehicle traffic, including street cars, pedestrians, and carriages.

A GOLDEN AGE

After Reconstruction, Indianapolis could no longer be considered a small town; it was a full-fledged city. Its transportation network, now dominated by railroads, reached to nearly every corner of the state and beyond, bringing products and raw materials into Indiana and delivering products and raw materials to the rest of the nation. Its population had gone from less than 20,000 in 1860 to almost 50,000 in 1870, and to over 75,000 in 1880. By 1890 its population had reached over 100,000, and by 1900 it stood at nearly 170,000. Farming would continue to be a major economic force outside of the city well into the twentieth century, but Indianapolis itself was no longer a farm town. Manufacturing combined with transportation to turn the city into a manufacturing and distribution center, with factories turning out products for the new urban and industrial age. The city would never return to its farming roots; instead, it would continue to grow and prosper while it took advantage of its central location to distribute the state's farming and industrial surplus.

Other trends took root that contributed to this new age of prosperity. Among these was the continued urbanization of the city as it expanded outward. The city also gained notoriety from publishing, its many famous authors, and the growth of its political power on the national stage. Together these trends have caused some to label the decades between 1880 and World War I as a "Golden Age." In some respects this is true. Literature and the arts flourished. Transportation greatly expanded, allowing people to move more easily than ever before. Manufacturing created great wealth, allowing people to enjoy more products and services to improve their lives. But there is a rush to over-generalize this time as other aspects are overlooked or minimized. While the 1860s saw the end of the Civil War and advances in transportation, the 1870s brought an economic depression. And while the 1880s saw further expansion in transportation, manufacturing, and the mechanization of agriculture, the 1890s were again a decade of economic depression. The literature of the age reflected these dualisms as it

presented both a positive and nostalgic view of the past, while at the same time presenting the problems of urbanization and industrialization. This is perhaps why much of the literature of the age is still relevant today—it provides a unique window into how contemporaries viewed the beginning of a new age.

In the period from the end of the Civil War to World War I, Indiana enjoyed unprecedented national attention over its politics. As the capital of Indiana, Indianapolis was at the center of determining how the state's politics played out. Many of the state's major political figures came from or lived in Indianapolis.

During the Civil War, Indiana politics had been intensely partisan, based on each party's positions on the major issues such as slavery, sectionalism, the expanding role of the federal government, and how Governor Morton conducted Indiana's war effort. The end of the war brought an end to some of these issues, but not all of them. For example, the war did not end the animosity between the two major political parties. Republicans and Democrats continued to differ on the status of African Americans. They also disagreed on how to deal with the defeated Confederacy. The radical Republicans called for more severe treatment of the South, while more moderate Republicans, led by Governor Morton, preferred a less punitive approach. Eventually the moderates saw the political advantage of taking a more radical stance against the defeated South because it allowed them to continue accusing the Democrats of supporting the Confederacy during the War. This would weaken the Democrats by making them less credible with the voters. The Democrats largely held the same positions they had held before and during the war, including opposition to Emancipation and to Governor Morton's conduct of the war. Specifically they feared that Emancipation would allow too many African Americans into Indiana, taking jobs away from white citizens, particularly in the cities such as Indianapolis.

As the post–Civil War era dawned, Indiana politics changed to meet new issues. But the dynamics of state politics remained much the same. There are several reasons why state politics continued to draw national attention, despite changing issues and personalities. That attention focused on Indianapolis. One reason was that neither party dominated from one election to the next. Elections were closely contested with margins of victory seldom more than a few percentage points. Voter turnout also was very high, especially in the cities, showing high voter interest in party platforms. Between 1880 and 1912,

voter turnout in Indiana fell below 90 percent only once, in 1892. During the same period, national voter turnout never rose above 80 percent, and actually declined.

Another factor propelling Indiana politics to the forefront was that state elections were held in October until 1880. This gave the national parties an early view on how the Midwest, and perhaps the nation, might vote in November. Indiana's total of 15 electoral votes also was one of the highest in the nation after 1870. This drew the attention of the national parties as well. Fifteen electoral votes could swing an election either way.

These factors combined to give Indiana its "swing state" status in the years after the Civil War and before World War I. Both parties concentrated their efforts on Indiana and similar states that could swing an election one way or the other. For Indiana, this meant rewards as both parties poured money into the state to swing its votes their way. It also meant Indiana candidates frequently appeared on national party tickets. There was a Hoosier on a major party ticket in virtually every election between 1868 and 1920.

During this time, one president and four vice presidents hailed from Indiana. The president was Benjamin Harrison. The vice presidents were Schuyler Colfax (vice president under Ulysses S. Grant), Thomas A. Hendricks (vice president under Grover Cleveland), Charles W. Fairbanks (vice president under Theodore Roosevelt), and Thomas Marshall (vice president under Woodrow Wilson).

Indiana also had four losing vice-presidential candidates during the same time: Thomas Hendricks (vice-presidential candidate with Samuel Tilden in 1876), William H. English (vice-presidential candidate with Winfield Scott Hancock in 1880), John Kern (vice-presidential candidate with William Jennings Bryan in 1908), and Charles W. Fairbanks (vice-presidential candidate with Charles Evans Hughes in 1916).

Eugene V. Debs, the famed Socialist party founder from Terre Haute, ran for president five times between 1900 and 1920, loosing all five races. The 1920 race was unique because he ran his campaign from the federal penitentiary in Atlanta, where he was serving a sentence for sedition. Former Governor J. Frank Hanly, the progressive reformer, unsuccessfully ran for president on the Prohibition Party ticket in 1916. Hoosiers also held other high positions in government during those years. For example, three Hoosiers served as U.S. secretaries of state during the 1890s through the first decade of the twentieth century: Walter Q. Gresham, John Foster, and John Hay. These

three men were largely responsible for forging U.S. foreign policy during the age of American imperialism.

Of those listed, several had Indianapolis ties or were from Indianapolis. Benjamin Harrison was elected the nation's 23rd president in 1888 and served one term. Originally from Ohio, Harrison moved to Indianapolis in 1854 after finishing his law studies in Ohio. He began his political career in 1857 when he was elected city attorney. In 1858 he became secretary of Indiana's Republican State Central Committee. In 1860 he campaigned for Abraham Lincoln and won election as the state's supreme court reporter. Harrison formed and served with the 70th Regiment in the Civil War. After the war, Harrison returned to his law practice and then ran for governor in 1876, but lost the race to Democrat "Blue Jeans" Williams. Five years later he was elected to the U.S. Senate, but served only one term because the Indiana State Senate voted not to return him. The following year he was nominated for president on the eighth ballot and won the election by a majority of the electoral votes, although he lost the popular vote. While Harrison was president, five new states entered the Union, the Sherman Anti-Trust Act and the McKinley Tariff were passed, and some of the first national parks were created. Harrison was nominated for a second term, but lost the election to Grover Cleveland. After leaving office, he returned to Indianapolis and practiced law until his death.

Like Harrison, Thomas A. Hendricks was born in Ohio. Shortly after his birth, his family moved to Shelby County where he attended school. In 1860, he moved his family to Indianapolis and established a successful law firm. He was elected to the state legislature in 1848 and served as a delegate to the state constitutional convention in 1850. In 1851 he was elected to the first of two terms in Congress. In 1863 he was elected to the U.S. Senate. In 1872 he was elected governor, the first Democrat to win that position in a northern state after the Civil War. Hendricks was nationally known for his oration and his opposition to Radical Republicanism. In 1876 he was nominated for vice president with Samuel Tilden of New York, but lost the election. In 1884 he was nominated again with Grover Cleveland and won, but his term was cut short by his death after only nine months in office.

Charles W. Fairbanks also was born in Ohio in 1852 and became a successful railroad attorney for the Indianapolis, Bloomington and Western Railroad after moving to Indianapolis in 1874. Fairbanks began his political career in the late 1880s by supporting Walter Q. Gresham over Benjamin Harrison for the presidential nomination. Four years later he became leader

of the Indiana Republican Convention and presided over election victories in 1894 and 1896. His friendship with William McKinley helped him win a U.S. Senate seat in 1897. Although he aspired to the presidency, his style of politics did not inspire national party leaders. He was viewed, however, as a good balance to Theodore Roosevelt and won a place on the ticket as vice president. After serving one term as vice president, Fairbanks was dropped from the ticket in 1908, partly because Roosevelt did not like Fairbanks and partly because of an incident that occurred in 1906 at Fairbanks's home in Indianapolis.

Fairbanks was hosting a party for visiting President Roosevelt, unaware that alcoholic beverages were being served. Fairbanks was a strict prohibitionist and was embarrassed by the subsequent newspaper references to "Cocktail Charlie." He made one last attempt at political office in 1916 as the vice-presidential running mate of Charles Evans Hughes, but lost the election to Woodrow Wilson and his Hoosier running mate Thomas Marshall.

Losing vice-presidential candidate William H. English was born in Scott County in 1822 and held several political positions early in his life, including secretary of the 1850 constitutional convention. He was elected to the Indiana House of Representatives from Scott County and served as speaker of the house during the 1851–1852 sessions. In 1853 he was elected to the U.S. House of Representatives and served five terms. During that time he worked on the Kansas-Nebraska Act, which allowed new states to decide whether they would enter the Union as free or slave states. But English was best known as an Indianapolis banker. In 1863 he and others formed the First National Bank of Indianapolis. English served as the bank's president until 1877 and after resigning his post, he invested his fortune in real estate and began construction of the famed English Opera House and Hotel. In 1880 English was nominated to be vice president on the Democratic ticket with Winfield Scott Hancock. After losing the close election, English retired from politics and participated in a number of civic activities for the remainder of his life, including service on the Monument Commission and as president of the Indiana Historical Society.

John W. Kern was born in Howard County and moved to Indianapolis in the 1880s to pursue a career in politics. His first election victory came in 1870 when he was elected reporter for the Indiana Supreme Court. He had run for the state legislature but lost that election. Kern would win only two of nine elections during his career. After moving to Indianapolis to practice law, Kern was elected to the Indiana State Senate in 1892. He ran for governor twice,

in 1900 and 1904. Kern ran for vice president with William Jennings Bryan in 1908, but lost the election to William Howard Taft. In 1911, he was elected to the U.S. Senate and served until 1916. During his term he was elected majority leader by his peers and effectively carried out a progressive agenda.

J. Frank Hanly was born in Illinois and moved to Indiana as a teenager. He served one term as governor (defeating John Kern in 1904) and was known as an independent Republican who often pursued a progressive agenda with or without the support of his party. Hanly also served one term as a U.S. Representative from 1895 to 1897. He also ran for the U.S. Senate in 1899, but lost the election to Albert J. Beveridge. Hanly is best known as a reformer of state government and as a prohibitionist. In 1916 he ran for president on the Prohibition Party ticket, but lost that election to Woodrow Wilson and fellow Hoosier Thomas Marshall.

Perhaps the best-known local politician during the late nineteenth and early twentieth centuries was Thomas Taggart, an Irish immigrant who rose to be three-time mayor of Indianapolis (in 1895, 1897, and 1899) and head of the Democratic National Committee. Taggart came to Indianapolis as an employee of a Union Station restaurant. Taggart was first elected to public office in 1886, as auditor of Marion County. He won re-election in 1890. During his time as auditor, he served as the head of the Democratic Party in Indianapolis, Marion County, and Indiana. Taggart was instrumental in securing Democratic Party victories throughout the late 1880s and 1890s. In 1888 and 1892, Marion County was carried by the Democratic Party presidential candidate largely due to Taggart. After serving three terms as mayor, Taggart and his business partners purchased the French Lick Springs hotel in Orange County, then one of the country's most exclusive resorts. While on the Democratic National Committee, Taggart served as its chairman from 1904 to 1908. Because of Indiana's political importance nationally, he was able to wield great power in national politics, including presidential races. In 1916, Taggart was appointed U.S. Senator to fill the vacancy left by the death of Benjamin Shively. That same year he was defeated for re-election.

Albert J. Beveridge represented the new wing of the Republican Party and stood in opposition to Charles W. Fairbanks, who represented the more moderate and traditional wing of the party. Beveridge was born in 1862 and came to Indiana in 1888 to attend DePauw University. After graduating, he read law and was admitted to the bar. Beveridge was politically ambitious and often spoke out in support of Republican issues. He was a strong supporter of

American imperialism and big business, but later in his career he shifted to a more progressive stance on many social issues. He was first elected to the U.S. Senate in 1899 and served two terms. But in 1911 the state legislature went Democratic and Beveridge was not elected to a third term. He continued to seek public office, but was caught up in the Republican Party split between William Howard Taft and Theodore Roosevelt's Bull Moose Party. Democrats took the White House in 1912 and again in 1916. In both elections, former Indiana Governor Thomas Marshall served as Woodrow Wilson's vice president. Beveridge never held public office again, but went on to write a definitive four-volume biography of John Marshall and was at work on a biography of Abraham Lincoln at the time of his death.

From the beginning, Indianapolis politics were characterized by some of the same factors as state politics. As the state capital, politics were centered there. Competitive, issue-oriented campaigns with high voter turnout marked elections for county and city offices. Organized parties and a diverse population ensured that the issues of the day would create differing positions. The diverse population was a result of Indianapolis's central location. Its settlers had come from the South, the Mid-Atlantic states, the New England states, and foreign countries. In each case, public reaction to issues such as governance, slavery, and the local economy depended partly on where the voter came from originally and the sentiments they brought with them. In the case of immigrants, the same was true.

The post–Civil War period also saw a flourishing of the arts in Indianapolis that earned the city national recognition. This "Golden Age" of literature did not emerge immediately or without foundation. Rather it came from a literary tradition in Indianapolis that dated back to the first decade of the city's existence. This foundation began with such people as Calvin Fletcher, who came to Indianapolis in late 1821. Fletcher's massive diary, published by the Indiana Historical Society, recounts his legal, political, and banking activities from the time of his arrival to his death in 1866. It is a richly detailed account of the city's first decades.

Samuel Merrill, another early settler, and the state treasurer at the time the capital moved to Indianapolis in November of 1824, brought with him from Corydon the contents of the incipient Indiana State Library. Merrill also established one of the city's first bookstores. Other bookstores were established during the early years after settlement, providing a source of new and traditional works for the public to read.

Another early source of information for citizens was the newspaper. As recounted earlier, papers began soon after the founding of the city. Within a few years, several papers were being published. Not only did they provide reasonably up to date information, they also provided an outlet for the opinions of the leading citizens of the new city. Newspapers also served as the only place for local authors to publish their works, including poets such as Sarah Bolton.

Other sources for the flowering of literature came in the form of literary clubs, lectures by noted authors and scholars, which became popular in the 1880s, and early histories of Indianapolis such as Ignatius Brown's 1857 history. Brown, a life long real estate lawyer, wrote the first detailed work on the subject. Lectures by noted authors and scholars placed audiences in front of contemporary thinkers who discussed the main social and political issues of the day. Another early historian of Indianapolis was Barry R. Sulgrove. Like Brown, Sulgrove was trained as a lawyer but ended up a writer, generally for newspapers. Sulgrove's massively detailed *A History of Indianapolis and Marion County* was published in 1884 and is still of use to modern historians.

With these movements underway for decades, the stage was set for an explosion of published literature that marked Indianapolis as a major center of not just authorship, but publishing as well. During the closing decades of the nineteenth century and the early decades of the twentieth century, numerous authors published essays, poetry, and novels that not only defined the modern age, but also the simpler life and sentiments of previous years. What is important here is the context in which these works were published. The modern industrial age had ushered in a period of change that was revolutionary to people in 1880, more familiar with a simpler, slower pace of life without machines, factories, and railroads. Many of the works published during these years harkened back to this simpler life, while taking a realistic look at their author's modern world.

Among the authors from Indianapolis and central Indiana made famous for their reflections on their time were the poet James Whitcomb Riley, humorist Kin Hubbard, novelists Meredith Nicholson, Booth Tarkington, Theodore Dreiser, Lew Wallace, Maurice Thompson, George Ade, George Baer McCutcheon, and Gene Stratton Porter. Among poets of his age, James Whitcomb Riley is perhaps the best known. Riley was born in Greenfield, just east of Indianapolis, and trained as a lawyer before turning his attention to writing. He worked for several small newspapers before joining the staff of the

Indianapolis Journal. He published his first poem in 1870. While working for the *Journal*, Riley began writing poetry and published his first compilation in 1883 under the title *The Old Swimmin' Hole and 'Leven More Poems.* Riley's popularity rose quickly. Soon afterward, he met William C. Bobbs of Merrill, Meigs and Company, one of the largest publishers in Indianapolis. For the next 25 years, its successor companies Bowen-Merrill and Bobbs-Merrill published more than three dozen of Riley's books of poetry. From the mid-1880s until his death in 1916, Riley was widely read and very popular on the lecture circuit. In the early 1890s, Riley moved to Lockerbie Street, on the east side of Indianapolis, where he lived for the rest of his life. Riley's work was noteworthy for its dialect and simple sentiments regarding a by-gone age. It is clear from his poetry that people were already feeling the differences between the life their parents led and life in a growing urban center.

The two most important novelists of the age were Meredith Nicholson and Booth Tarkington. Nicholson was born in Crawfordsville, Indiana, in 1866. He worked at a variety of jobs until settling in as an editor at the *Indianapolis News* from 1885 to 1897. In 1891 he published a book of poetry, but his literary fame began with the publication of *Hoosier* in 1900, a history of Indiana. Over the next 30 years, Nicholson published numerous novels, essays, poetry, and other works. His most famous work, *The House of a Thousand Candles*, published in 1905, was a mystery set in northern Indiana. Seven years later, his *A Hoosier Chronicle* examined the changes Indiana underwent as it entered the twentieth century. After the Depression started, Nicholson did not complete any more novels, but remained active as a diplomat and a newspaper writer during World War II. His diplomatic portfolio included appointments as minister to Paraguay, Venezuela, and Nicaragua. Nicholson is barely read today, but at the time he was considered one of the most important authors of his time for his portrayals of people's lives in changing times.

Like his contemporary Meredith Nicholson, Newton Booth Tarkington was a novelist, playwright, and essayist. But unlike most of his contemporaries, Tarkington's work had a harder, more realistic edge to it, often vividly describing the conflicts people experienced in a new urban-industrialized society. Tarkington was born into a prosperous household, and much of his later writings were based on how society's elite coped with their lives in the new age. From the time he was a boy, Tarkington was interested in the arts and having a good time. His consumption of alcohol was legendary. While attending Purdue and Princeton Universities he began his writing career, but

he didn't graduate and instead returned to Indianapolis to pursue a career as an illustrator and writer. His first published novel *The Gentleman from Indiana*, won him wide acclaim. His second novel, *Madame Beaucaire*, also met with acclaim, but it was his novels from 1913 to 1921 that made him one of the most popular and important authors of the twentieth century. *Penrod* and *Seventeen* were popular for their characterizations, but his most famous works *The Magnificent Ambersons* and *Alice Adams* are considered his best for their portrayals of realism in a time of change. Tarkington won Pulitzer Prizes for both.

Two other major developments occurred at the turn of the century that solidified Indianapolis as a major manufacturing and transportation center: the development of the interurban system and the rise of the automobile industry. Both modes of transportation were not only new to Indianapolis, but to the nation as well. Both changed cities in ways no one anticipated. The automobile was more revolutionary than the interurban and would have a more lasting effect on the city. But initially, the interurban was more important because it was faster to affect the city. Both allowed Indianapolis to expand, tying the city to its outlying neighborhoods. Both allowed people living outside the city to more easily travel to the city, and allowed city services to expand outward into rural areas.

The Indianapolis auto industry produced elegant cars, but generally in small numbers. Few people could afford them. While one of the largest automobile makers in terms of different types of cars, the Indianapolis automobile industry failed to adopt Henry Ford's and Detroit's mass production techniques. At the same time, Indianapolis did not deal with large numbers of semi-skilled laborers or the growing labor movement. Nor did Indianapolis begin to deal with the congestion caused by automobiles until traffic lights were introduced in 1925. Parking meters were not installed until 1939. But automobiles did lead to more paved roads eventually. In the first two decades of the twentieth century, autoworkers outnumbered workers within other industries, but their share of the workforce declined during and after the 1920s. Indianapolis's automobile industry remained small, dominated by several manufacturers who never had the capital to invest in mass production equipment. Even if they had desired to do so, they did not have the backing of local bankers or businessmen. As a result, the local automobile industry could not and did not survive the Depression. But while the automobile industry flourished, it produced some of the best and most expensive cars in the world. In the first years after the turn of the

century, dozens of Indiana cities were producing cars. Indianapolis led the way, producing over 60 different makes of cars, including Lexington, Parry, Marmon, Waverly, Stutz, Ford, Frontenac, and the Ideal. Most of these were short-lived models; some were produced for only a year or two. But some, such as the Stutz, were produced for more than 20 years.

Other examples of early Indianapolis automobiles include the Waverly Electric, the first battery-powered car. It was produced from 1898 until 1909. Arthur C. Newby and Charles E. Test formed the National Automobile and Electric Company in 1900. It produced an electric car in 1902 and a gasoline-powered car in 1904. The electric car was sold until 1911. Their cars were considered high quality, but also expensive.

The Overland Company moved to Indianapolis in 1905 from Terre Haute with the financial support of David Parry, the buggy maker. But besides Parry, there was little financial support from the local community, so it moved to Toledo, Ohio in 1909. In that year the company produced 5,000 automobiles.

The largest automaker in Indianapolis during the early years was Ford. The Indianapolis production facility was part of Ford's plan to build branch plants in order to avoid freight charges to local markets. Ford began producing automobiles in Indianapolis in 1914 and at its peak produced 25,000 cars a year.

Joseph Cole was an Indianapolis carriage maker who began to make cars in 1908 with backing from Harvey Firestone. By 1912, Cole was producing 2,000 cars per year. Cole turned down an offer to merge with General Motors and continued to expand his production until the recession after World War I caused a decline in sales. Cole closed in 1924.

Marmon built its first car in 1902 and went into full production in 1905 at the Nordyke and Marmon Flour Milling Machinery Company. It was a Marmon that won the first Indianapolis 500 in 1911. It was a successful company but never earned the needed profits to keep up with the larger manufacturers. At its peak in 1929, Marmon produced 22,000 automobiles. The last model was a 16-cylinder car produced in 1931. The plant closed in 1934 because of the Depression.

Henry C. Stutz moved to Indianapolis in 1903 and built a race car for the 1911 Indianapolis 500. In 1913, Stutz built its first production car. Peak production of 2,200 cars in 1917 was followed by financial problems. Investors kept the company alive, but as with Marmon, the Depression stopped Stutz's production in 1934.

INDIANAPOLIS

Of all the cars produced in Indianapolis, the most elegant was the Duesenberg, especially the Model J. Fred and August Duesenberg first built bicycles and engines for boats and cars. During World War I, they prospered building boat and airplane engines. After the war, the company moved to Indianapolis to build race cars. Its first production models were unprofitable until it re-organized with the help of E.L. Cord's Auburn Automobile Company in 1926. Duesenberg's best car was the Model J, built between 1929 and 1934. The car was far too expensive for most people, costing thousands of dollars. Only 481 were built. Like so many others, the Depression hit the Duesenberg Company hard and it failed in 1935.

At about the same time that automobiles were first appearing on the streets of Indianapolis, another type of public transportation was making its first appearance in the city: interurban cars. The Indianapolis, Greenwood, and Franklin line made its first run in early January, 1900. A second line, from Greenfield to Indianapolis, soon followed. Within a year, nearly 200 miles of interurban track were in use and within the next several years, over 2,000 miles of track were in operation in over three-quarters of Indiana counties. By 1910, 12 companies operated lines to most of the biggest cities in Indiana, except Evansville, in the far southwest of the state. There were few early indications that interurbans would be successful. Equipment failed, electrical service was inconsistent, and traffic congestion soon became a serious problem. Photographs of downtown Indianapolis shortly after the turn of the century show how serious the traffic problem had become, as cars, interurbans, wagons, and foot traffic filled the streets with little apparent order. The problem only got worse until the interurban traffic could be better coordinated.

That was accomplished with construction of the Traction Terminal in 1904, on the east side of the capital building, where the current Adams Mark hotel now stands. At the time of its construction, approximately 100 interurban cars came into the city each day from ten different tracks. By the end of the first decade of the twentieth century, that number quadrupled. Nor was the interurban just a passenger system, bringing people into and out of the city. Interurbans also transported freight from farms into the city and manufactured goods back to small towns throughout Indiana. Interurbans carried more freight and more people than railroads and made many more stops along each route. Freight and passenger charges were also considerably cheaper than similar fares on railroads. As the system expanded, so did its

services. Parlor and dining cars were added, but increased automobile sales and the expansion of paved roads cut into interurban services. Smaller lines went out of business or were merged with more profitable lines. The Depression of the early 1930s dealt a death blow to the interurban system. Through consolidation, the interurban system continued to run through the 1930s, but by 1941 the last line, between Indianapolis and Seymour, ended its run.

It was during the Golden Age that the future symbol of Indianapolis was built. Since the razing of the Governor's Mansion in the late 1850s, little had been done with the Circle except to allow animals to graze there. Following the Civil War, the site was cleaned up and renamed Circle Park.

The Indiana Soldiers and Sailors Monument was first suggested by Governor Oliver P. Morton shortly after the Civil War ended. After 20 years of lobbying efforts on the part of many people, the Indiana General Assembly formed a commission in 1887 to plan the construction of a monument on the Circle to honor Indiana's Civil War veterans. In 1888, a proposal by German architect Bruno Schmitz won the international design competition. His design called for an obelisk shaft, made from Indiana limestone, decorated with statuary and surrounded by pools and fountains. The cornerstone (on the northeast corner) was laid in August 1889, and contains the names of all Indiana soldiers and sailors who served in the war, plus both Indiana constitutions, and a 38-star U.S. flag. Shaft construction was completed in 1892. In 1893, the Victory statue that crowns the monument was installed. The 30-foot tall, 10-ton bronze statue, also known as Miss Indiana, faces south to welcome home returning soldiers. Its sword represents victory, its torch represents the light of civilization, and its eagle represents freedom.

Other statuary was installed over the next several years. At the base of the monument, an infantry soldier faces southeast, a cavalryman faces southwest, an artilleryman faces northeast, and a sailor faces northwest. Astragals banding the shaft honor the Navy and the Army, while the upper astragal has "1861" facing south and "1865" facing north. Plaques on the outside of the shaft commemorate Hoosiers who served in all previous wars before the Civil War.

Construction of the remaining statuary dragged on through the decade, but by 1901 the monument was completed at a cost of just under $600,000. The monument was formally dedicated on May 15, 1902, with General Lew Wallace, James Whitcomb Riley, and other dignitaries in attendance. Visitors

to the monument could either walk up the stairs or take an elevator, as they can to this day.

The monument has remained almost unchanged since its dedication. In 1945, and again in 1957, repairs were made to the Victory statue to ensure its stability. In December 1962, the monument was decorated for the holiday season for the first time. For 42 years, that tradition has continued as "the world's tallest Christmas Tree" is lit on the day after Thanksgiving. From 1986 to 1990 the monument went through an extensive renovation, including the installation of climate control, a new elevator, major exterior and interior cleaning, and a transparent observation deck, where visitors can view the entire city in any direction. In 1999, the Colonel Eli Lilly Civil War Museum opened below the main shaft of the monument. In 2002, the monument celebrated its centennial.

HEART OF THE NATION

By the early twentieth century, Indianapolis was a large, modern city. Its population had swelled to nearly 170,000. By 1930, its population had nearly doubled to over 300,000. It was a diverse city, but not an integrated one. Its number of foreign born continued to rise to nearly 20,000 by 1910, but would begin to decline afterward and continue its downward trend for several decades to come. It wasn't until 1960 that the percentage of foreign born would climb again. Most minorities and foreign born lived in defined neighborhoods and enjoyed comparatively few of the benefits of an urban society compared with white citizens. They were poorer, with fewer opportunities and less education.

Automobiles and interurbans jammed the streets with little traffic control. The same streets bustled with pedestrian traffic moving among hundreds of businesses and banks. Indianapolis had become one of the largest cities in the Midwest and was no longer as isolated as it had been a century before. Roads, railroads, and interurbans fanned out in nearly every direction as more and more people moved into the city and its suburbs. The Hoosier capital was tied to every other city in the state and beyond. Indianapolis had become part of the twentieth century: urban, industrialized, and congested.

Over the next several decades, events would change forever the nature of the city along with its place in the country and the world. These decades would be flanked by world wars, both of which directly affected the city. In the intervening years, there would be radical changes in politics as the Ku Klux Klan dominated the Republican Party in the 1920s and New Deal politics dominated the Depression era.

Before World War I, the residents of Indianapolis had little in the way of a world view. While it is true that Indianapolis was a thriving community, connected to the rest of the nation economically, socially, and politically, it was just as inward looking as the rest of the nation. There was an awareness of world events, but little involvement. Indianapolis, like other cities, was concerned with its own development. The pace of that development was

dizzying. New buildings sprang up seemingly overnight. Banks, department stores, and other businesses thrived. L.S. Ayres and Company, the William H. Block Company, L. Strauss, and Charles Mayer were among the biggest department stores and brought the latest fashions to the city. These stores were important not only because they represented a mature business economy, but also because they represented a changed economy—the products of an urban, industrialized economy that no longer relied on agriculture alone to supply the needs of its people. The products were new, the methods of production were new, and the ability to buy such products was unprecedented in Indianapolis and the nation.

There were universities, hospitals, and theaters where stars from New York regularly performed. Indianapolis was rich with cultural institutions, best exemplified by the English Opera House and Hotel. Located on the northwest corner of the Circle, the Opera House first opened in 1884, built by Indianapolis banker William H. English. Actors such as Lawrence Olivier, Sarah Bernhardt, and George M. Cohan performed on its grand stage. The auditorium seated 2,500 and was the largest theater in the city. A large, luxurious hotel was added later. The complex stood as a destination for decades until it was demolished in 1948 to make way for a J.C. Penny store.

Like much of the nation in the fall of 1914, Indianapolis enjoyed a kind of splendid isolation. While aware of the outside world, it all seemed far away and remote. World War I was seen as a European war. German citizens of Indianapolis largely supported the Allied powers, but sought no direct involvement. There was an active peace movement in the United States and in Indiana as well, called the Indiana Peace Society. There didn't seem to be any direct threat to the United States, and certainly no threat to Indiana or its capital city. But there was sufficient concern for leading citizens to call for a level of preparedness. Among those making the call were such prominent citizens as Booth Tarkington and Lucius B. Swift. But it was not until the eve of America's entry into the war that the public became galvanized in support of America's involvement. Once war was declared in 1917, Indianapolis quickly fell into line in support of the American war effort. Newspapers, businesses, and politicians called for unity and support to defeat the Central Powers.

The most important organizing body created to run the city's war effort was the Marion County Council of Defense, part of the Indiana State Council of Defense. The council consisted of leading business leaders. Among the organizations that worked under the umbrella of the council were the Patriotic

Garden Association of Indianapolis, the Liberty Kitchen, the Child Welfare Committee, the Red Cross, and the War Work Council.

Many businesses also contributed to the war effort by concentrating their production lines to produce war-related materials. Among them was the Allison Speedway Team Company, founded in 1913 by James A. Allison, co-founder of the Presto-Lite Company and the Indianapolis Motor Speedway. In 1917 the company name was changed to the Allison Engineering Company. Originally the company supplied parts to the Nordyke and Marmon Auto Company. During World War I, it supplied parts for the Liberty aircraft engine, as did Nordyke and Marmon. The Presto-Lite Company, originally a maker of acetylene cylinders for automobile headlights, supplied munitions and the Indianapolis Gas Company supplied explosives.

The city participated in other ways to help the national war effort. Among these were the four Liberty Loan campaigns, raising a total of nearly $25 million, along with donations to the Red Cross and other charitable organizations. The city also sponsored parades in honor of troops headed for Europe. Patriotic organizations were formed and rallied in support of the troops. Fort Harrison hosted several officer training camps and the Indianapolis Motor Speedway became an airport for aircraft repair and refueling.

For Indianapolis, the ugliness of war manifested itself not in battle but in suspicion of the city's German population. Although common in war, it was unwarranted because the vast majority of German-born or those of German ancestry were completely loyal to the United States. Before America's entry there had been suspicion of German activities throughout the United States, partly because some Germans called for America not to send munitions to the Allies. Local "Protection" committees were set up and Governor Goodrich established paramilitary "Liberty Guards." The Indianapolis Common Council passed Ordinance 35 in 1917 outlawing disloyalty to the government. After the war started, suspicion turned to hostility. The teaching of German was banned, names of German institutions were changed, and laws were passed allowing authorities to gather information on suspicious citizens and activities. Schools held patriotic exercises to produce items for the soldiers, such as socks. Teachers even had loyalty clauses added to their contracts.

Before the war, some local Germans openly supported their country and called for America to stay neutral. After America's entry into the war, most supported the American cause. But this did not stop the press, the public, and the government from viewing them with suspicion. Some German institutions

became targets of vandalism. Despite these actions, the German community as a whole remained loyal.

After the armistice, there were celebrations and festivities throughout the city. In May of 1919, there was a huge parade downtown for returning soldiers. Many of them joined veteran's organizations such as the American Legion and the Veterans of Foreign Wars. In 1920, the state legislature authorized the construction of a memorial and a headquarters of the American Legion. Two blocks were set aside from Vermont to North Streets and between Meridian and Pennsylvania Streets. The architects were selected in 1923. Their design called for two American Legion buildings, one on the east side of the grounds and the other on the west side. Both were to be in the neoclassical design. The first was built during the 1920s, but the second was not completed until the 1950s. Construction on the memorial began in 1927 but was not finished for many years. General John J. Pershing laid the cornerstone on July 4, 1927. Construction continued into the 1930s, some of it under the Works Projects Administration, a New Deal program. Because of the Depression and other delays, the memorial itself was not completed until 1965.

With World War I over, the 1920s ushered in a decade of unprecedented economic growth and cultural flowering. Indianapolis's population was over 314,000. The decade began with Prohibition, the long-sought ban on the sale of alcoholic beverages. But like in other cities, the ban meant little as the liquor trade went underground. Bootlegging and speakeasies flourished. As a transportation center, Indianapolis became a focal point for the distribution of liquor. Alcohol came in from the southern and eastern states and from Chicago. As in other cities, there was corruption as politicians and law enforcement often looked the other way, sometimes in exchange for payoffs.

Along with Prohibition, Indianapolis saw the rise of another movement that left a lasting mark on the city. That was the rise of jazz and an active music industry. Ragtime and ethnic music in general found a friendly environment in Indianapolis. African-American brass bands often played at the Washington Theater. Blues were also popular at the Washington and Golden West theaters. The jazz movement had moved north from New Orleans and other southern cities and found a large black population in Indianapolis, which embraced it. It began in the speakeasies and vaudeville houses and soon found enthusiastic followers in theaters, bars, and other venues. While Indianapolis may not have been as prominent a jazz city as New Orleans, New York, or Chicago, it was an important city for the performance of jazz, especially within the

African-American community. Many major jazz musicians performed in the city's African-American theaters along Indiana Avenue. Indianapolis was a city of jazz enthusiasts and performers and became an important stop for jazz musicians as they moved from city to city.

A much more disturbing movement also took root in Indiana and Indianapolis during the 1920s. The Ku Klux Klan movement began as a thinly veiled social movement, preaching patriotism, prohibition, family values, and education. But under the veil was a political agenda that promoted bigotry and anti-Semitism. At its peak, at least 25 percent of men in Indianapolis belonged to the Klan. The Klan had several incarnations before the 1920s, being founded in 1868 in the southern states during Reconstruction. The new Klan that was founded in 1915 was best known for its anti–African American sentiments, but also included elements of anti-Semitism and anti-Catholicism.

The new Klan was organized at Stone Mountain, Georgia, in 1915 by William Henry Simmons. After Simmons was replaced by Dallas dentist Hiram Evans in 1922, the Klan began to expand northward. Evans selected Evansville salesman and World War I veteran Dwight C. Stephenson to organize the new Klan in Indiana. Stephenson was born in Texas in 1891 and worked at a variety of jobs before coming to Indiana in 1920. Stephenson also had been a member of the Socialist Party before coming to Evansville. There he became involved in Democratic Party politics. He ran unsuccessfully for Congress in 1922 after he moved to Indianapolis, and late in 1922 he was named grand dragon of Indiana and 22 other northern states.

Stephenson became wealthy and powerful as grand dragon of the Indiana Klan. He was so powerful that he essentially controlled the Republican Party in Indiana during the mid-1920s. His wealth came from the sale of Klan memberships, clothing, and publications. The Klan newspaper, the *Fiery Cross*, had a circulation of 125,000. At the height of Stephenson's power there were between one-quarter and one-half million male Klan members in Indiana. This number does not include women or children affiliates.

From his downtown office, Stephenson directed the affairs of the Klan. His success as head of the Klan came as a result of his ruthlessness and his organizational abilities. He sent out Klan recruiters, who held held meetings and signed up new members throughout the state. He also funded political campaigns, including John Duvall's mayoral campaign in Indianapolis and Ed Jackson's gubernatorial campaign in 1924. Both would later be forced to

resign after Stephenson was convicted of murder in 1925. Stephenson also controlled the police department, city hall, and the school board.

Stephenson's control extended to other aspects of Indianapolis civic life. Crosses were burned in citizens' yards. Marches of intimidation took place near Catholic churches and Jewish synagogues, citizens were beaten, and businesses were vandalized. But there was opposition to Stephenson and the Klan. Leading the way was the *Indianapolis Times* newspaper, the American Legion, and the Catholic Church, whose priests refused to be intimidated by Stephenson's violent tactics. But Stephenson's eventual downfall came from none of those opposed to him. Instead, it originated from his own violent action directed against a young state employee.

At Governor Jackson's inaugural banquet in January of 1925, Stephenson met Madge Oberholtzer, a 28-year-old office worker in the Department of Public Instruction. On Sunday, March 15, 1925, Oberholtzer was kidnapped by Stephenson's bodyguards and forced to travel by train to Hammond with Stephenson. Along the way Stephenson raped and severely beat Oberholtzer. The next day, she attempted suicide. She was driven back to Stephenson's home in Indianapolis and held there until Tuesday, when she was taken home. Stephenson was arrested and charged with assault. When Oberholtzer died on April 14, the charges were changed to murder. During his trial, Stephenson claimed he was framed by Hiram Evans, his old Klan mentor with whom he had a falling out several years earlier. Stephenson was convicted of second-degree murder and sentenced to life in prison. He served more than 30 years in prison, and was released in the late 1950s. His conviction and the subsequent exposé on the Klan in the *Indianapolis Times* spelled the end of the Klan's power in Indiana. Public opinion quickly turned against them and all it represented, especially with Stephenson's revelations about political corruption in city hall.

The decade of the 1930s was dominated by two events: The Great Depression and the election of Paul V. McNutt as governor. The Depression brought enormous upheaval to the capital city. The one-term governor brought New Deal solutions to a conservative city and state.

The 1920s were a decade of growth and prosperity. When the stock market collapsed on Tuesday, October 29, 1929, few expected the economic downturn to be so severe or to last so long. Business and political leaders felt the local economy could withstand the downturn. It had done so before and it would do so again. But the effects were both deeper and more widespread

than expected. Businesses suffered because people had much less money to spend and inflation caused the dollar to be worth much less. Many businesses could not withstand the downturn and closed. Banks closed, as did factories, putting thousands out of work. Housing foreclosures soon followed. Within three months, nearly ten percent of the workforce was out of work. Within a year, the unemployment rate had climbed to 17 percent. Some businesses went from employing full-time to just part-time. Without the welfare net that exists today, unemployment spelled disaster.

During the early 1930s, the employment figures continued to decline. By late 1931, the unemployment rate stood at 25 percent above 1929 levels and would continue to a high of 37 percent by the spring of 1933. The manufacturing workforce was hit hardest, with a decline of 50 percent by 1933. The construction and real estate businesses also ground to a halt with virtually no new construction during the early 1930s.

Early on there were attempts to provide relief for both businesses and the private sector. Civic leaders continually urged businesses and factories to reduce layoffs and closings as much as possible. But more formal efforts were needed by the state and federal governments. A year after the Depression started, the Emergency Work Committee was formed to organize fundraisers and to determine who would receive aid and in what amounts. Usually this was done on the basis of work for money or work for food. This was a precursor to New Deal work programs because much of the work the committee provided money for was used for cleanup and repair within the central city.

Despite the generalized downturn in the economy, there were some success stories. For one, as bad as the situation was, it was worse in other cities where the economy was less diversified. Among the construction projects begun were Lockfield Gardens, a low-cost apartment/housing complex; Marion College, which opened in 1937; and the Indiana State Library, which opened in 1934.

But these successes were the exceptions, not the rule. Across the board, change did not come until the initiation of New Deal legislation, starting in 1933. The administration of New Deal programs came under Governor McNutt, Indiana's most powerful and important governor of the twentieth century. McNutt was the first Democratic governor elected in 16 years, in part because the Depression had begun under a Republican administration. Born in Franklin, just south of Indianapolis, in 1891, McNutt had a meteoric

rise to power. After graduating from Indiana University, he took a law degree from Harvard and became dean of the Indiana University School of Law at age 34 in 1925. In 1928, McNutt became the national commander of the American Legion. In 1933, at age 42, he became governor of Indiana. McNutt's strategy for pulling Indiana out of the Depression was twofold. The first step was to implement New Deal legislation. The second step was to radically reorganize state government to make it more efficient and make the implementation of New Deal legislation more efficient and widespread. In doing so, McNutt built a powerful political machine that influenced state politics until the 1980s.

One advantage McNutt utilized was that the Democratic Party enjoyed control over both the Indiana House of Representatives and the Indiana State Senate. He used this advantage to quickly push through his reorganization of state government. He instituted the state's first income tax as well as other taxes. But the most sweeping change came in the structure of the government itself. He reduced the state's cumbersome agencies to eight departments including executive, commerce and industry, audit and control, education, public works, state, law, and treasury.

Like Governor Morton 70 years earlier, McNutt centralized much of the government power in his office. With his authority over government, even his own party criticized him for having too much power. Indiana's constitutions had been written in a way to avoid too much executive power. But like Morton, McNutt was able to sidestep this by placing allies in key departmental positions. With the institution of New Deal legislation, McNutt took quick action to institutionalize the new Social Security system as well as other programs, particularly public works programs such as the Civilian Conservation Corps.

Under the National Recovery Act, 1933 proved to be the worst year of the Depression. But unemployment figures began to decline and public works projects began to have an effect as new construction under the Civilian Works Administration picked up. Lockfield Gardens was built under the CWA, as were the Naval Armory on White River and the Women's Prison on east Michigan Street. The Civilian Conservation Corps also provided much needed help by employing thousands in its projects throughout the state.

By the summer of 1934, unemployment had dropped to 20 percent. Within two years, new businesses began to open downtown. It would still be several more years before full recovery was attained, but the worst was over.

It took direct involvement in World War I for the nation's isolationist tendencies to be broken, and it was much the same for World War II. Before the attack on Pearl Harbor on December 7, 1941, the nation was again inclined toward isolationism. The same was true in Indiana and Indianapolis. As was the case before World War I, there was an active peace movement. The majority of people did not want intervention on behalf of the European allies. After the attack on Pearl Harbor, that changed too. Isolationism disappeared, as did the active peace movement.

For Hoosiers, in Indianapolis and throughout the state, World War II was a war of participation and of production. Indiana sent more than a quarter-million troops to war and more than 10,000 died. For the home front, it was an economic war—the goal being to produce what the nation needed for war. Nearly $8 billion dollars in government contracts were let in Indiana. The needs of the home front effort in support of the war superceded all other needs until the end of the war. These efforts caused many changes at home.

The biggest observable changes for the state and for the capital city in particular were in the production of war matériel. Nearly $1 billion in federal money was spent in building the facilities of war production. The most important new construction came in munitions facilities. More than two dozen munitions plants were built in Indiana, including Camp Atterbury south of Indianapolis, Jefferson Proving Grounds, Crane Naval Ammunition Depot, Charlestown Ordinance Works, and others. Most of these were located in southern Indiana, hit hard by the Depression, and slow to recover. On otherwise unproductive land, tens of thousands of Hoosiers were put to work building the facilities and then assembling the munitions.

Indiana also produced much with its heavy industry, such as oil and steel from Gary, and machine parts from the automobile industry. Of the three industries, the automobile plants had the greatest conversion task because the oil and steel industry simply had to continue what it had been doing for decades. Most of the production took place in the cities: Indianapolis, Gary, and Fort Wayne. Facilities in Evansville and Jeffersonville produced shipping for the Navy.

Indianapolis's contributions to the war effort were many and varied. Its main military installation was Fort Benjamin Harrison, located on the city's northeast side. Built in the early twentieth century to help facilitate the expansion of the U.S. military, Fort Harrison served as one of the nation's main troop induction

facilities for most of the war because of its central location and easy access by road and railroad. In that capacity, Fort Harrison inducted six million soldiers into the military, more than any other facility in the United States. The fort also was greatly expanded during the war, which meant jobs and federal dollars poured into the city. Included in this was the Army's finance center. Fort Harrison continued to serve as the Army's payroll center until the early 1990s. Fort Harrison also housed a large hospital used to treat wounded soldiers during the War. In 1944, after the induction center was moved to Camp Atterbury, German and Italian prisoners of war were housed at the fort.

Indianapolis also housed other, smaller military facilities during the war including Stout Field, where paratroopers were trained, and the Naval Armory, where radio operators were trained. Two ordnance plants and several chemical depots also were built in Indianapolis. As with other cities, Indianapolis rationed such commodities as rubber, metals, and sugar. And like other cities, Indianapolis went through blackouts and drilled for air raids. Although Victory Gardens did not play a role as it did in World War I, there were citizen drives for food, clothing, money, rubber, and other items needed by the military. Allison's built 20,000 engines for military aircraft and Curtiss-Wright made tens of thousands of propellers. By the end of the war, 20 firms in Indianapolis accounted for $600 million in federal expenditures. Marion County as a whole accounted for nearly $2 billion in federal expenditures. One-third of all wages in Indianapolis during the war were war-related, which was the fourth-highest rate in the nation.

Although World War II never directly threatened Indianapolis or Indiana, there was an incident at the end of the war that deeply affected the city and still does to this day. On the morning of July 16, 1945 (the same day the atomic bomb was first tested in Nevada), the heavy cruiser U.S.S. *Indianapolis* sailed from San Francisco with top secret cargo: components of one of the atomic bombs targeted for Japan. The ship was to proceed to the island of Tinian, drop off its cargo, and continued its voyage to Guam and then Leyte, in the Philippine Islands. Escort vessels would have slowed her down, so she sailed unescorted. Besides, most cruisers could outrun enemy submarines. But Captain Charles McVay was not told that an American destroyer had been sunk in the same waters only days earlier. Nor was he told that as many as four Japanese submarines were thought to be along his route between Guam and Leyte.

At about midnight on July 29, Japanese submarine I-58 fired at least two torpedoes at the *Indianapolis*. The first tore off 40 feet of the *Indianapolis's* bow.

The second hit amidships, exploding a magazine and severing communications throughout the ship. Without communications, engineers didn't know whether they should continue moving or stop. They continued moving forward while thousands of tons of water poured into the bow. The *Indianapolis* sank in 15 minutes, taking about one-third of her complement of 1,197 crewmen. About 880 survivors went into the water, many of them severely injured. By the time they were rescued several days later, only 317 were still alive. The rest had been eaten by sharks, or had succumbed to a variety of injuries.

News of the sinking was not released until after the atomic bombs had been dropped in August. Immediately, questions were asked regarding the ship's mission and why she had sailed alone. The Navy offered few answers, partly because her mission had been so secret, and partly because the Navy was unwilling to admit the confusion that had surrounded her sinking. No SOS had been sent and no one paid any attention when she did not report in at Leyte on July 31. It was the policy of the Navy not to announce the arrival or non-arrival of combatant ships. The *Indianapolis* also was the flagship of the Navy's Fifth Fleet and it was possible that Admiral Raymond A. Spruance might have redirected it to another destination.

The sinking of the *Indianapolis* was the greatest disaster in American naval history, but the implications for the Navy were far worse. Admiral Ernest J. King, chief of naval operations, felt the Navy had won the war. Such a disaster would paint the Navy and Admiral King in a much less positive light. The very future of the Navy was at stake, especially in anticipation of its being downsized after the war. Of the hundreds of American ships sunk or lost during the war, not a single captain was court-marshaled until the *Indianapolis* incident.

An inquiry held on Guam in August recommended that Captain McVay be court-marshaled for failing to "zig-zag," (which was his option) and for failing to order abandon ship soon enough (even though the communications system had been destroyed by the second torpedo). McVay was acquitted of the second charge, but was found guilty of failing to zig-zag. This despite the testimony of the Japanese submarine captain, who testified that he would have sunk the ship anyway. Subsequent controversy regarding the conviction caused the Navy to remit the sentence, but not the conviction. McVay remained in the Navy until 1949, when he retired as a rear admiral. In 1968 he committed suicide. To this day the Navy refuses to release all of the information it has regarding the incident or the subsequent investigations. But

finally, after decades of protests by the survivors, Congress passed legislation in October 2000 expressing support for the exoneration of Captain McVay. President Bill Clinton signed the legislation. In July 2001, the Navy secretary officially amended Captain McVay's record, exonerating him for the sinking of the U.S.S. *Indianapolis*. But the Navy still refuses to remove the conviction for failing to ziz-zag, which remains on McVay's record.

PEACE AND CHANGE

Like other time periods in the history of Indianapolis, the post–World War II period was a time of growth, change, and adaptation. Three factors of change dominated this time, which taken together resulted in the transformation of Indianapolis into a vastly different city. The changes were shifts in the economic base of the city, changes in the city's transportation system, and changes in how the city and county were governed.

From the end of World War II until the 1979–1982 economic recession, the diversified local economy continued to grow, but it also changed as the manufacturing base eroded and new economic forces altered the very structure of the local economy.

World War II had been a boon to the Indianapolis economy. Because the local economy did not rely on just one industry, it was not weakened by the post-war reduction in production of war-related materials. Factories retooled back to automobile parts and durable goods, both of which helped to refuel the local economy in the post-war boom. Some new factories were even built on the Indianapolis east side that employed thousands for decades. When the same plants and others like them closed during and after the recession of 1979–1982, they were symptomatic of the shift away from traditional manufacturing and toward the service and technical sectors. From the 1970s on, there was a decrease in the number of manufacturing jobs and a corresponding increase in the number of lower paying, service sector jobs. This was especially true as the larger factories closed and their employees could no longer find similar high paying jobs.

But there were other factors at work as well. Among them were the oil shortages of the 1970s, the rise of Asian manufacturing of durable goods and automobiles, and corporate mergers that replaced local management with management not based in Indianapolis or Indiana. Such mergers frequently resulted in layoffs and less local control over decisions that directly affected the local economy. In the case of mergers, the corporate goal was out-of-state profits instead of benefits to the local economy. While

INDIANAPOLIS

Indianapolis's local economy allowed some of the manufacturing loss to be absorbed by local high tech manufacturing, the losses locally still numbered in the thousands of jobs.

Another factor of economic change was the move of retail shops and other businesses out of the central city and into the burgeoning suburbs. As the city expanded, more and more people moved out of the central city. To accommodate the growth in suburbs, retailers and other businesses began to move out of downtown and build closer to the new suburbs. Especially important was the growth of the large malls. At first, such malls as Glendale were not covered and represented an accumulation of stores built close together. But Glendale was not particularly convenient when still exposed to the variable Indianapolis weather. Once malls were built as environmentally-controlled shopping complexes that offered most conveniences, further growth was fostered. Malls such as Lafayette Square, Washington Square, and Castleton Square could soon be found on all sides of Indianapolis. Greenwood Mall, originally built without a roof, was eventually covered and gave the south side of town the same convenience as the other sides of town enjoyed. Other retail outlets soon followed, particularly strip malls and later, the larger discount-department stores. So while traditional manufacturing was on the decline in the central city, retail shopping, once largely confined to downtown, became just as convenient in the suburbs, further debilitating the central city's economy.

Indianapolis was not the only city to suffer from shifts in the economy. These were national trends and the federal and state governments played roles in both contributing to the decline of inner cities and in providing relief. During the late 1970s and early 1980s, there were cutbacks in federally funded programs that previously had been aimed at helping inner cities make the transition to an economy based less on manufacturing. These cutbacks forced cities to look for new sources of aid. Some of those sources turned out to be the states themselves as new partnerships were formed between cities and state governments. New relationships were also forged between cities, local businesses, and private groups. Local chambers of commerce also played a role by more aggressively marketing their cities.

There was still some federal aid in the form of tax reductions for downtown areas under re-development. Frequently these central areas focused on a major downtown landmark, such as Indianapolis's Union Station, a decayed and abandoned complex filled only with the homeless and decades of debris

and waste. Union Station was renovated in the 1980s and served as a focal point to re-invigorate part of downtown with shops, restaurants, and a hotel where sleeping quarters were located in railroad cars. Indianapolis followed the lead of other cities by building a large downtown convention center in the mid-1970s with the hope of using it to attract large conventions, exhibits, and other events where large numbers of people would gather and contribute to the local economy. This also meant that new hotels had to be built to house the travelers, and new restaurants erected to feed them. But while re-development was occurring, there was no stopping the move to the suburbs or suburban retail development. Neighborhoods that surrounded the central city continued to decay. What were once the suburbs of the central city began to suffer the same fate as the inner city itself.

While urban areas were adapting to the changing economy, there was another recession in the late 1980s. This was caused in part by the savings and loan scandal and the collapse of the real estate bubble that accompanied it. Downtown areas that were just beginning to recover from the recession of a decade before found themselves with property values decreasing, as property tax revenue declined.

The second factor of change that altered Indianapolis was the further development of its transportation system. Transportation developments were both an outgrowth of the expanding city and a cause for the deterioration of the inner city itself.

When World War II ended, the city returned to its pattern of automobiles, street cars, and buses providing transportation for its citizens. Street lights and parking meters had been installed, but the congestion continued to worsen. Studies in the 1950s and 1960s called for additional one-way streets, widened intersections, and other improvements, including mass transit. But this last recommendation was never instituted and is only now under further consideration with the first link, called People Mover, operating between Methodist Hospital and the Indiana University Medical School complex.

By the mid-1950s, only cars and buses were being utilized by the residents of Indianapolis. The bus system was subsidized by federal, state, and local taxes, but these funds have continually decreased since the 1970s and 1980s.

By far the most important transportation system in Indianapolis has been the Interstate Highway System, authorized by Congress in the 1950s as a national transportation and defense highway system. It was mostly completed in the 1970s and consists of more than 40,000 miles of highway.

INDIANAPOLIS

Indianapolis is intersected by four interstates. I-70 bisects the city from east to west and continues on to St. Louis and Columbus, Ohio. I-74 comes up from Cincinnati and swings around the city, heading northwest to Peoria, Illinois. I-65 is a southeast to northwest interstate between Chicago and Louisville, Kentucky. Like I-70, it bisects the city downtown in what is called the Spaghetti Bowl. I-69 comes southwest from Michigan and ends on Indianapolis's north side.

Only the southwest quadrant of the city is without an interstate, but plans are underway to extend I-69 southwest to Evansville, Indiana. A route has been selected and environmental impact studies are underway. Once these are completed and federal funding is secured, Indianapolis will serve as the focal point for the most extensive interstate system in the nation.

These interstates have contributed to Indianapolis being called the Crossroads of America. No other American city has more interstates coming in and leaving the city—four interstates going in six different directions. Again, Indianapolis's central, accessible location has allowed its transportation system to develop so that it serves the needs of the city. These highways not only brought travelers and visitors to and from the city, but also allowed manufacturing businesses and retail outlets to develop along their routes. They made suburbs more accessible and therefore more attractive. Interstates allowed suburbs to grow and provided the city an opportunity to expand further and further from the central city, ironically contributing to the decay of the central urban area they were created to serve.

The final piece of the post-war transportation system was the interstate that looped the entire city. I-465 forms a complete 55-mile ring around the city, connecting all the interstates and other major roads into and out of Indianapolis. Upon its completion it also furthered the development of suburbs because every suburb had access to every other part of the city. Barring traffic jams, one could travel by car between any two parts of the city within 30 minutes.

Built at a cost of over $100 million, construction on the first segment of I-465 began in 1962, on the northwest side of town. Originally designed as a four-lane highway, it was widened to six lanes before completion and has been continuously updated ever since. The eastern side of I-465 underwent further widening in the late 1990s and early 2000s and now comprises 12 lanes. Further plans call for more widening of the other sections until the entire loop has 12 lanes.

The interstate system that surrounds and penetrates Indianapolis has contributed much to the city. It allows access to and from the city and furthers suburban growth as well as business, retail, and manufacturing development outside of the central city. The highways have also helped reduce downtown congestion. But while the interstate system has fostered such commercial and residential growth, it also contributed to the continued evacuation of the city by those same businesses and residents. The rebuilding of the central city began in earnest in the 1980s and continues to this day with more than $2 billion spent in the last 20 years on downtown redevelopment.

The third major element of change that affected Indianapolis after World War II was in the area of governance and politics, specifically the creation of "Unigov," or unified government, which unified city and county government in the late 1960s. The process was complex and controversial, given that it was accomplished without a public referendum. Nor was it as complete as it seemed. But it did result in a fundamental shift not only in the way the city was governed, but in who governed it. The dominance of the Republican Party would stand out as a major effect of the creation, and that dominance would last for a generation. It was not until the 2003 municipal elections that Democrats would hold both the mayor's office and a majority on the city-county council. Republicans dominated the city-county council from 1968 until 2003 and the current mayor, Bart Peterson, was the first Democrat to be elected mayor since the mid-1960s.

Before Unigov, there were separate city and county governments. City government consisted of a nine-member common council and a mayor, along with 16 municipal corporations, each with its own governing board. The municipal corporations controlled such government functions as the Indianapolis Airport Authority, the Health and Hospital Corporation, the Indianapolis–Marion County Public Library, the Metropolitan Development Corporation, the Indianapolis Parks Department, and the Human Rights Commission, among others. There also were nine township governments. The common council was elected at four-year intervals with each party submitting six candidates, one for each district. The top nine of twelve were elected. Each party was guaranteed at least three seats. The mayor also was elected every four years and had appointment and veto power. Until the mid-1960s, the mayor had been forbidden from seeking a second term. Although mayors were considered powerful, one-term mayoral terms weakened their power because continuity was not possible.

INDIANAPOLIS

The last Democratic mayor before Unigov, John J. Barton, created the Greater Indianapolis Progress Committee to help chart Indianapolis's future and help carry out the mayor's agenda. Sitting on that committee as well as on the school board was Richard G. Lugar, the first mayor under Unigov and considered by many to be the architect of Unigov. But a greater role was probably played by Marion County Council President Beurt SerVass, who led the combined city-county council for a generation after Unigov. SerVaas met with a group of reform-minded Republicans throughout 1968 and came up with the proposal for unifying city and county government. The group decided that the task could best be accomplished without a voter referendum or a constitutional amendment.

In the 1968 elections Republicans swept nearly all city, county, and state offices. With Republicans in place who favored reorganization, Mayor Lugar formed a 40-member Government Reorganization Task Force to propose the necessary legislation for the Indiana General Assembly. The plan they developed called for a unified county-wide governing council led by a mayor. Some municipal functions would be brought under the control of the mayor, while others would be left independent. For example, the schools, the police department, and the fire department would not be consolidated. Township government also would be left intact. Incorporated cities with populations over 5,000 would be excluded as well. Four towns within the county fit this qualification: Speedway (home of the Indianapolis 500), Lawrence (in the northeast part of the county), Beech Grove (in the southeast part of the county), and Southport (on Indianapolis's south side). County offices mandated by the state constitution also were excluded. This included auditor, clerk, recorder, sheriff, and treasurer. Six of the sixteen municipal corporations remained independent: the Capital Improvements Board, the Health and Hospital Corporation, the Indianapolis Airport Authority, the Indianapolis Public Transportation Corporation, the Indianapolis–Marion County Public Library, and the City County Building Authority.

After successful votes in the Indiana House of Representatives and the Indiana State Senate, the bill creating Unigov was passed in the 1969 session and became effective on January 1, 1970. On that day, the five-member Marion County Council and the nine-member City Common Council merged to form the city-county council. This was an interim move meant to fill any void in leadership until the municipal elections of 1971. In those elections, Richard Lugar was re-elected mayor for a second term and a new 29-member

city-county council was elected. This system remains in effect today. Republicans remained in control of the council until the 2003 elections when Democrats won a majority 15 seats for the first time. Democratic Mayor Bart Peterson also won re-election to a second term, the first Democratic mayor to hold office since Lugar's first win 30 years earlier.

Unigov radically changed governance and politics in Indianapolis. It greatly expanded the size and population of Indianapolis as well as solidified Republican control of the council and the mayor's office for a generation. The city grew from just over 80 square miles to almost 370 square miles, nearly the size of Marion County itself. The city's population swelled from just under one-half million to nearly three-quarters of a million. Those eligible to vote grew by about 25 percent, from just under 300,000 to over 400,000. Most of those were Republican suburbanites.

The city-county council stood at 25 members, one from each district, and four at-large members. Each member's term was set at four years with elections held in the year before presidential elections. The power base lies both in the mayor's office and in the council. While there are no term limits on either, there are checks and balances. The mayor proposes budgets and the city-county council either approves or rejects the budget. The mayor has veto power, but the city-county council can override the mayor's veto with a two-thirds majority vote. But the veto power does not extend to constitutionally mandated offices such as the courts or the independent municipal corporations. The mayor also appoints deputy mayors, department heads, and other office holders, but his appointments are subject to approval by the city-county council.

There are six departments within the executive branch including Administration, Metropolitan Development, Parks and Recreation, Public Safety, Public Works, and Transportation. Of the 16 municipal corporations that existed before Unigov, six remained after consolidation: the Capital Improvements Board, the City-County Building Authority, the Health and Hospital Corporation of Marion County, the Indianapolis Airport Authority, the Indianapolis Public Transportation Corporation, and the Indianapolis–Marion County Public Library. Although the municipal corporations operate independently, their boards are appointed by the mayor and city-county council and their budgets are reviewed by both.

Exceptions to the consolidation include some elected officials of Marion County (assessor, auditor, clerk, coroner, prosecutor, recorder, sheriff, and

treasurer) who are elected in presidential years. The Marion County Election Board and the Board of Voter Registration also remain independent. Most duties formerly carried out by Marion County commissioners now are performed by the mayor's office. Other exceptions include the Marion County courts and the township governments. Even some of the municipalities included in the consolidation retain some governmental functions, as long as those functions don't interfere with the overall functioning of Unigov.

In such a complex structure with included and excluded towns, overlapping services, separate township governments, and independent municipal corporations, Unigov had to establish what were called Special Service Districts and Special Taxing Districts. These assured that necessary city services were provided for all residents of the county, while also assuring that the tax and service burdens were spread out over the entire area requiring such services, such as law enforcement.

There were of course problems and concerns in such a complex system. For Democrats, consolidation meant an erosion of their power base within the city, particularly Center Township, because many Republicans from the other eight townships tipped the balance in favor of the Republican candidates for mayor and the city-county council. Another problem that emerged after the inception of Unigov was that the African-American population, which generally voted Democratic, had its voting percentage diluted with the addition of tens of thousands of mostly white voters from the suburbs who generally voted Republican. Prior to Unigov, African Americans comprised more than 25 percent of the city's population. After Unigov, that figure fell to less than 20 percent. Since then, it has continued to decline as a percentage of total population. While Republicans argued that an increased tax base would benefit African Americans, those agencies inner-city African Americans relied on, such as public schools and welfare, were excluded from the control of Unigov. A third problem with Unigov is that voter participation has continued to decline since it began, even though it was thought that Unigov would provide greater accountability and therefore greater participation by the electorate. In the 1971 municipal elections, the percentage of the voter-age population casting votes was about 54 percent. In the 1975 elections, it was slightly less. But since then, the percentage has steadily declined to a low of about 35 percent throughout the 1990s.

The creation of Unigov was not the only political development in Indianapolis during the post–World War II years, though it was certainly the

most important. The John Birch Society was a product of the Cold War and exerted some influence on the national scene during the 1950s and 1960s. Although no longer considered a viable political movement, the John Birch Society was one of several ultra-conservative, anti-Communist organizations that arose as a result of the expansion of Communism after World War II. The society began in Indianapolis in December 1958, when a group of 11 men met at a local residence and formed a charter. Robert Welch was named president and remained the front person for the society for many years. Always a shadowy group, the John Birch Society was named for an American soldier who was killed in China shortly after the end of World War I. Known mostly for its anti-Communist literature, the society fell out of favor during the 1970s, although its telephone number could still be found in the phone book. After the fall of Communism in the late 1980s and early 1990s, the John Birch Society disintegrated and is no longer a viable movement.

A NEW CITY

In this new century, the city of Indianapolis, encompassing all of Marion County, boasts a population of more than 860,000. The population of the Metropolitan Statistical Area is over 1,600,000. The total area of the city is 396 square miles, making it one of the largest cities by land area in the United States. Ethnically, the city is 70 percent white, 24 percent African American, and 4 percent Hispanic. Its African-American population is the 16th largest in the United States and the 6th largest in the Midwest. Indianapolis's Hispanic population is the fasting growing population in Marion County.

Indianapolis's unemployment rate hovers around five percent and its cost of living index is seven percent below the national average. The average price of a single family home is about $137,000. Indianapolis is the home of NBA and NFL franchises and annually hosts the two largest single-day sporting events in the world—the Indianapolis 500 and the Brickyard 400.

Indianapolis is the home of the largest children's museum in the world and the newest state museum in the nation, where hundreds of thousands of visitors each year learn about their past and their future. The new, revitalized downtown gleams with 500-foot skyscrapers and an urban mall visited by nearly a million people each month. The Convention Center/RCA Dome complex regularly hosts thousands of visitors for its trade shows, conventions, and sporting events.

Indianapolis has one of the largest urban universities in the nation with nearly 30,000 students, while the nation's third largest medical school complex occupies hundreds of acres just west of downtown, an area that once was scarred by urban decay and neglect. The new White River State Park is a model for urban parks where families can walk along the Central Canal, visit several museums, or enjoy an outdoor concert at an amphitheater on the banks of the White River.

Given the conditions facing Indianapolis 30 years ago, the turn-around has been a remarkable success story. In that span of years, Indianapolis has remade itself—again. After the economic decline of the 1970s, the city was left with a smaller manufacturing base, a much larger city, and virtually no national reputation except for the appellations "Naptown" and "India-no-place." Amidst the economic decline, the upturn was already being planned, but no one noticed yet. Indianapolis was not yet a destination, but a stop along the way to Chicago, Louisville, Cincinnati, or St. Louis.

As the largest landlocked city in the United States, Indianapolis's civic leaders took a hard look at the city and began the process of remaking it for the future. Indianapolis was the quintessential "Rust Belt" city, and its leaders knew it. By the late 1960s and early 1970s there grew a determination to remake the city into a destination. What the plan resulted in is a new, vibrant downtown with a large downtown mall, thriving professional sports franchises, new cultural institutions, a large urban university, and billion-dollar construction projects such as the United Airlines Maintenance Hub and a new billion-dollar airport, scheduled to open in 2008.

But it's been more than billion-dollar construction projects that have brought Indianapolis back. It was a calculated strategy begun in the late 1960s to rebuild the city and its image based on the strengths of the city, and then aggressively marketing the city to the nation and the world. The plan called for capitalizing on what Indianapolis saw as its strengths: location, a growing sports industry, and a diverse economy that could sustain growth in both of them. Now, in the new century, Indianapolis is not simply a place to pass through, but a place to visit. It is a destination like never before.

This process of change began when Unigov was formed. It ushered in an age of Republican domination of the mayor's office and the city-county council. For the next 30 years, Republicans stayed in control. While Republicanism alone is not responsible for the rebirth of Indianapolis, the consistency of governance, the vision of civic leaders, and dynamic leadership are the factors responsible. With the knowledge that Indianapolis had no image, it was not so much a matter of changing an image, but a matter of creating one that was marketable.

Spurred by the Indianapolis Chamber of Commerce and the Greater Indianapolis Progress Committee, and later by the Indiana Sports Corporation,

the Indianapolis Partnership, and other organizations, the city began to redefine itself by turning its negatives into positives. Without mountains or oceans to impede access, Indianapolis lauded its location as a destination. The key to success was to make that destination desirable. The first decisions toward that goal included a new convention center and a new sports arena for the city's NBA franchise, the Indiana Pacers.

Market Square Arena opened in September 1974 as the new home of the Pacers. Located at the intersection of Market and Alabama Streets, Market Square Arena was one of the first construction projects built by a public-private partnership. Along with the renovation of the century-old City Market across the street, Market Square Arena revitalized the east side of downtown. At the time of its construction, it was the fifth-largest sports arena in the United States, with its dome rising 150 feet above the arena floor. The dome spanned 364 feet. The unique construction of the dome allowed every seat a full view of the arena floor. At its greatest capacity, Market Square Arena could seat over 18,000 fans. Later that capacity was reduced when a restaurant was added. In the 25 years of its existence, Market Square Arena hosted basketball games, concerts, circus performances, and numerous other events. But by the middle 1990s, it was determined that a new arena was needed. When Conseco Fieldhouse was completed, Market Square Arena was imploded on July 8, 2001, and turned into a temporary parking lot. Current plans call for twin towers to be built on the site housing condominiums, shops, and restaurants.

The Indiana Convention Center opened two years before Market Square Arena, in 1972. It was built at a cost of over $26 million and was the city's first major convention hall. In 1984, the first of several renovations was completed with the addition of the Hoosier Dome. Shortly afterward, the city was rewarded for its $80 million investment when the Baltimore Colts moved to Indianapolis. The Hoosier Dome was one of the largest construction projects ever in downtown Indianapolis. The dome's roof is 19 stories high and weighs 257 tons. What makes the roof so notable is that it is made of fabric, held up by air pressure supplied by a series of 100-horsepower motors. It is one of only six such domes in the nation. At the time of construction, the Hoosier Dome held over 60,000 seats. The entire dome covers more than seven acres, while the fabric roof covers eight acres.

INDIANAPOLIS

In 1993, a $45 million expansion added more than 50,000 square feet of exhibit space to the Convention Center/Hoosier Dome complex. At the same time, renovations were made to the dome and sponsorship was added by RCA. A further $20 million were spent to renovate the RCA Dome in 1999. Luxury suites were added as the overall seating was reduced to a little over 57,000. The RCA Dome is now one of the smallest and oldest domed stadiums in the nation. Just two years later, an additional 100,000 square feet of exhibit and meeting space were added to the Convention Center, making the total square feet of the complex more than 400,000. A new 600-room Marriott Hotel was added at the same time, making the Convention Center/RCA Dome accessible to 3,000 hotel rooms, all within walking distance.

Since opening in 1984, the RCA Dome has hosted numerous major sporting events besides the ten NFL games each year, that alone bring millions of dollars to the city every time a game is played. Among the events hosted there were the 10th Pan Am Games in 1987, the 1991 World Gymnastic Championships, and the 1991, 1997, and 2000 NCAA men's basketball Final Four Championships. Recently the NCAA announced that over the next 35 years, the RCA Dome (or its replacement) will host the NCAA men's Final Four once every five years.

In the 32 years since the Convention Center opened, dozens of national and international events have been held there, including religious conventions, trade shows, business conventions, and other events. The Indianapolis Convention and Visitor's Association records the number of booked room-nights as a gauge of how successful these conventions and events have become. Since the mid-1980s, room-nights have continued to rise from about 230,000 in 1987 to a high of nearly one-half million in 2001. Since the mid-1990s, numbers of delegates to these same conventions and meetings have numbered more than three-quarters of a million or more per year. Major events continue to be booked years into the future. In 2004, the Southern Baptist Convention will be held in Indianapolis for the second time, bringing 50,000 visitors to the city for a week. In 2005, the Church of the Nazarene will hold its convention here. Also in 2005, the NCAA women's basketball Final Four Championship and the men's first and second rounds will come to Indianapolis. In 2006

and again in 2010, the NCAA men's Final Four Championship will return to Indianapolis.

Sporting events at the RCA Dome are not the only events that come to Indianapolis. The business of sports was considered a centerpiece for the making of Indianapolis's image. The effort to focus on sports as a tourist attraction and as business has greatly benefited the city. Since the 1970s, more than 400 sporting events have been held in Indianapolis, events that have brought the city more than $1 billion in revenue and more than 4.5 million visitors to the city. Among the other events held here have been the 1982 National Sports Festival, the 1991 PGA Championship, the inaugural Brickyard 400 NASCAR race in 1994, the inaugural United States Grand Prix Formula One race, the 1996 United States Olympic Swimming and Diving trials, the 2000 United States Olympic Swimming Trials, the 2001 World Police and Fire Games, and the 2002 World Basketball Championship. During the next six years Indianapolis will host the United States Gymnastic Championships and the Solheim Cup in 2005.

Among the sports-related organizations headquartered in Indianapolis include the NCAA, which moved to the new White River State Park in 1999, the United States Gymnastics Federation, the United States Track and Field Association, the American College of Sports Medicine, the National Institute of Fitness and Sport, and numerous state sports organizations.

Other major sports venues include Conseco Fieldhouse, the Indiana University Natatorium, and Victory Field. Conseco Fieldhouse replaced Market Square Arena as the home of the Indiana Pacers. Located directly east of the Convention Center/RCA Dome complex on Georgia Street, Conseco Fieldhouse cost $183 million and is considered one of the best basketball arenas in the country. Besides hosting the Pacers, Conseco Fieldhouse also houses the WNBA's Indiana Fever and the Arena Football League's Indiana Firebirds. Concerts, hockey, soccer, and other events are also held at the fieldhouse. Seating over 18,000 with 69 luxury suites, Conseco Fieldhouse is the cornerstone for the revitalization of the downtown Wholesale District.

The Indiana University Natatorium, located on the Indiana University/ Purdue University campus, is considered one of the finest swimming and diving venues in the world. Its swimming pool has adjustable lengths and its diving pool is 18 feet deep with five platforms and three springboards.

The natatorium has hosted numerous swimming and diving championships including the Synchronized Swimming World Cup Championships, the National High School Swimming and Diving Championships, 11 United States Olympic trials and 14 NCAA Swimming Championships.

Victory Field is the home of the Indianapolis Indians, the city's AAA baseball team. The new facility, built on the grounds of Kingan and Company in 1996, cost $18 million to build and seats 13,500 fans. The open-air facility has the feel and appearance of older style baseball stadiums.

The last major element on Indianapolis's sports résumé is auto racing. The premier venue for racing anywhere in the world is the Indianapolis Motor Speedway. The brainchild of automobile pioneer Carl Fisher, the track was built in 1909 to test automobiles. At the time of its construction, the area was farmland, lying about five miles west of downtown. Partnering with James A. Allison (who had co-founded the Prest-O-Lite Company with Fisher), the two-and-a-half mile oval was originally built with crushed rock and tar. Later in 1909, the surface was replaced with over three million ten-pound bricks. In 1927, Fisher and Allison sold the track to World War I flying ace Eddie Rickenbacker, who sold the track to Terre Haute businessman Anton "Tony" Hulman in 1945. Since the mid-1930s, most of the bricks had been covered with asphalt. World War II put an end to work at the track, but after the end of the war Hulman finished covering the track with asphalt for the 1962 race.

Renovations continue at the track to this day. Recently a new tower, Gasoline Alley, and grandstands have been added. Every May, the Indianapolis Motor Speedway hosts the largest single-day sporting event in the world—the Indianapolis 500. Since the inaugural race in 1911, millions of racing fans have patiently filed into the two-and-a-half mile oval to see the fastest open-wheeled auto racing in the world, where speeds can reach as high as 240 miles per hour on the straightaways. The speedway has 250,000 permanent seats, but for decades tens of thousands of fans also sat in the infield on race day. In recent years, infield seating has been reduced as more grandstands are erected. It is not unusual for half a million fans to see the race on the last Sunday in May each year.

Since 1994, the speedway has also hosted a NASCAR Race—the Brickyard 400. In 2000, Formula One racing returned to the United States when the inaugural United States Grand Prix ran at the speedway. Part of the infield

was converted to a Formula One track and the rest of the race was run on the 500 track itself.

Another key element in revitalizing downtown was the long-planned Circle Center Mall. In the 1980s, the city began planning for a large downtown mall similar to the one in Columbus, Ohio. Originally planned as a $1 billion complex, the scaled-down version opened in 1995 at a cost of more than $300 million. Two square blocks of older buildings were demolished while eight historic building facades were saved and incorporated into the mall to give the appearance of renovated buildings. The mall consists of 800,000 square feet of retail space. Nordstrom's and Parisian serve as anchor stores, while nearly 100 other stores, restaurants, and nightclubs fill the remaining space. There is also a nine-screen cinema complex. Perhaps the most visually stunning architectural feature of the mall is the Artsgarden, a 12,000 square-foot glass-enclosed dome that serves as the northwest entrance to the mall and that extends over Washington Street. The Artsgarden is an exhibition, meeting, and marketing space for the local arts community. Directly across the street from the Artsgarden is one of the few remaining empty lots in downtown Indianapolis. For years, the city couldn't decide what to do with the prime space. In early 2004, the city announced that a new 220-room luxury hotel, the Conrad, would be built on the corner. The Conrad Hotel is scheduled to open in 2006.

The economic impact of Circle Center Mall on Indianapolis has been enormous in the first nine years of operation. In the first five years alone, the economic gain for the city has been estimated at over $2 billion. On opening day, 60,000 people visited the mall. In the first year, the mall saw 12 million visitors. On an average, 800,000 people visit the mall each month.

In recent years, development has concentrated on the west side of downtown, especially along the renovated Central Canal. Demolition of older factories, such as the Beveridge Paper Company, has cleared the way for new apartments, new businesses, and museums. Most of this development has been part of the new White River State Park, a unique urban park designed as a showcase for visitors and residents alike. White River State Park encompasses nearly 300 acres between Washington Street on the south and New York Street on the north. The park also spans both sides of White River.

INDIANAPOLIS

The original plan called for a domed stadium, a new zoo, museums, and a 700-foot open air tower visitors could climb to see a panoramic view of the city. Because it was to be an urban park, many state legislators were reluctant to support the plan because it would not directly benefit their constituents. Another controversy was that there was no concrete plan for the administration of the park or how the rest of the park would be developed after the new Indianapolis Zoo opened on the site in 1988, after a $63 million fund-raising campaign that included private and corporate donations and grants from the Lilly Endowment and Krannert Charitable Trust. The new Indianapolis Zoo encompasses 64 acres on the west side of the White River, on the site of the former Kingan and Company meat packing plant. The zoo was built on the "biome" concept, where animals live in environments that duplicate their natural habitats.

After the zoo opened, several ideas were considered for other venues in the park. Some thought an urban park should feature urban-centered themes such as family entertainment, while others felt that the park should feature more nature-oriented themes. The newly formed White River Park Commission sought input from theme park developers such as Knott's Berry Farm. But no general developer was ever selected. By the early 1990s, the legislature had cut off funding for further development, but Governor Evan Bayh restored funding through an executive order. Also, by the late 1980s the Eiteljorg Museum of American Indians and Western Art opened and it seemed clear that the White River State Park would feature family entertainment as its main theme.

The Eiteljorg Museum of American Indians and Western Art was the first museum built in White River State Park. Largely funded by industrialist Harrison Eiteljorg and grants from the Lilly Endowment, the Eiteljorg Museum is one of only two museums east of the Mississippi River to collect and exhibit both Native-American and Western-American art. Its three galleries feature art from Native-American and Western-American artists as well as Native-American historical objects and sculpture by artists such as Frederic Remington and Charles M. Russell.

The Eiteljorg Museum opened in 1989 and attracts more than 100,000 visitors each year. Much of the collection comes from Harrison Eiteljorg

himself, who collected Western and Native American art for decades as well as African and Oceanic art, much of which is at the Indianapolis Museum of Art. The rest of the collection at the Eiteljorg comes from a merger between the Eiteljorg Museum and the Museum of Indian Heritage, that had been located in Eagle Creek Park, on the northwest side of Indianapolis. The main building of the Eiteljorg resembles a large pueblo from the American southwest. A large Kiva-like structure in front of the museum serves as an entry point from the underground garage, shared by the new Indiana State Museum.

The last major project for White River State Park is the new Indiana State Museum, completed in May 2002 at a cost of $65 million. This newest addition to the park is a two-building, state-of-the-art facility built of limestone, stainless steel, brick, and glass. The 272,000 square-foot facility had been in the planning stages for decades.

The Indiana State Museum was originally formed in 1869 as a geology "cabinet." For most of its early years, it was a natural history-oriented facility. By the turn of the twentieth century, its collection had expanded to include cultural history objects. For most of the twentieth century, it was housed on first the third floor, and then the basement of the Indiana Statehouse. During those years the museum languished, and after a 1958 study called it the worst state museum in the nation, the Indiana legislature finally started to act. While in the statehouse, the museum consisted of objects crammed into glass cases with little interpretation and virtually no staff. After the new city-county building was completed in the early 1960s, the old city hall was leased by the state for $1 per year and converted into the "new" Indiana State Museum.

This 85,000 square-foot facility was built in 1909 on the corner of Alabama and Ohio Streets, on the east side of downtown. The four-story structure was a beautifully ornate neoclassical structure with a limestone exterior, marble floors, and an 85-foot atrium that reached from the first floor all the way to the roof. But already by the 1970s it was clear that even this facility was inadequate for the museum's growing collections. In 1982 the "Team Tomorrow" study called for a large addition to the north side of the building, but no action was taken. In the mid-1980s, another study was done that called for a new structure to be built on the west side of downtown, where the Acme-Evans grain silo complex and an old school were located.

INDIANAPOLIS

Momentum was building for a new museum when an incident took place that delayed construction for a decade. Before preservationists could stop the demolition of the school (called School 5), the building was torn down. Some members of the community were so outraged that a new museum became politically impossible. It wasn't until the late 1990s that the momentum was regained and the state legislature passed a bond issue for construction of the new facility. Coincidentally, the site where the new state museum was to be built eventually became the site of the new NCAA headquarters. The new state museum ended up lying between the NCAA headquarters and the Eiteljorg Museum. Construction began in 1999 and was completed in 2002. During its first year of operation, nearly 600,000 visitors came through the museum.

The Indiana State Museum is a two-building complex. The exhibit building is 172,000 square feet with 65,000 square feet of permanent exhibit space, a large central lobby, two restaurants, a two-story gift shop, and several meeting rooms. The exhibit space is divided into five natural history galleries on the first floor, five cultural history galleries on the second floor, and more than 10,000 square feet of temporary exhibit space on the third floor. The second building is 100,000 square feet and contains eight storage rooms for the museum's vast collections, as well as offices, meeting space, construction shops, conservation labs, and a large gallery featuring exhibits about Indiana's future.

Certainly the largest construction project ever undertaken in Indianapolis was the United Airlines Maintenance Hub at Indianapolis International Airport. Construction began in August 1992 on the $900-million facility. Indianapolis was not one of the original 90 bidders for the project when in 1989 United Airlines announced that it was planning to build a maintenance hub for its Boeing 737 and 757 jets to relieve pressure on its San Francisco hub. United wanted a hub that would be easily accessible and was also looking for incentives to help with the enormous costs of the project. At nearly the last minute, Indianapolis put together a package of nearly $300 million in tax breaks and other incentives.

Indianapolis was selected because of this incentive package and because of its central location. Construction began on Phase 1, involving 200 acres of the 300-acre complex, soon afterward. Half the projected 11 hangers and

18 aircraft bays were part of Phase I. Successive phases of construction were scheduled for completion by 2004. At full employment, projected to be by 2004, the facility was expected to employ more than 6,000 workers.

After the terrorist attacks on New York and Washington, D.C. in 2001, United began a series of massive layoffs that eventually hit the Indianapolis Maintenance Hub. Late in 2002, the airline announced that it was declaring bankruptcy. Early in 2003, United announced that it was closing the ten-year-old facility. At the time, the hub employed 2,600 workers. Fortunately for Indianapolis, in 2003 the Indianapolis Airport Authority announced that it was embarking on another $900 million facility—a new midfield terminal to replace the aging and undersized existing terminal. That project, now under construction, is expected to be complete and operational by 2008.

The closing of the United Airlines Maintenance Hub was not the only loss Indianapolis suffered in the manufacturing sector in the last few years. Indiana as a whole has suffered the loss of tens of thousands of manufacturing jobs as plants throughout the state have closed or outsourced their work to other nations where labor costs are cheaper. Since 2000, Indiana has lost 90,000 manufacturing jobs. The state has led the nation in the rate of job loss. In 2004, Indianapolis's Daimler Chrysler foundry will close, eliminating 1,000 more jobs. But because of Indianapolis's diverse economy, the losses will be absorbed more easily than in other cities where manufacturing is a larger part of the economy. But it may not be that simple. Certainly the recession has been a prime cause of continued job loss in the manufacturing sector, but a changing economy is another reason. But despite criticism that Indianapolis has been slow to adapt to changes in the economy, the city has not been idle in reacting to the changes either. Change and adaptation have always been keys to Indianapolis's success.

The loss of manufacturing jobs is not a new trend in Indianapolis. It's been occurring since the 1970s and 1980s when automobile and other large manufacturing plants on the city's east side began to close. For Indiana and Indianapolis there have been two problems associated with these changes. The first is that the job losses continue to occur over a long period of time, indicating a trend the city has not successfully dealt with. The second is that the city has not been successful in embracing the new technologies and industries that are replacing manufacturing. Recent studies indicate there

are two solutions. The first is to convert to a more technologically based economy and the second is that the education of Indianapolis's workforce must improve and adapt to meet the needs of the changing economy. The stated reasons are that education must be updated to keep Indiana and Indianapolis's workers in Indiana and to attract more workers and more technologically-based industries here.

Two signs of progress have recently emerged. In 2003, construction began on the new Indiana University/Purdue University School of Informatics on the IUPUI campus. This new technology-based school will focus on the application of information technology to a modern, changing economy. It is one of the first such schools in the nation to devote its entire curriculum on the future application of information technology to industry and other sectors of the economy.

Another initiative that began two years ago is the BioCrossroads program. In 2001, a study by the Battelle Memorial Institute indicated that Indiana was not investing in the emerging life sciences sector of the economy as much or as fast as other states. The Indiana General Assembly passed legislation approving an economic plan that included life sciences initiatives. One of the initiatives was called the Central Indiana Life Sciences Initiative.

The Battelle Study identified three areas of the economy Indiana and Indianapolis should develop: advanced technology, information technology, and life sciences. With the leadership and support of the IUPUI Medical School, Eli Lilly and Company, the Cook Group, Guidant, Roche Diagnostics, and other companies, the Central Indiana Life Sciences Initiative changed its name to BioCrossroads and began to develop a plan with the goal of expanding Central Indiana's life sciences industries primarily through public-private partnerships and workforce development. The mission of the BioCrossroads program is to attract and create jobs and companies in the life sciences to make central Indiana a center of innovation in the business of enhancing health. To that end, several steps have already been taken to further define how Indianapolis should proceed, including establishing a downtown research community tied to the IUPUI Medical School, defining and marketing strengths within the existing local life sciences industry, recruiting for

and retaining for the existing life sciences industry, and promoting conventions and trade shows.

Indianapolis continues to move forward in other ways as well. Discussions within city/county government have been underway for several years regarding the increasing traffic congestion in and around the greater Indianapolis area. Parts of the city already suffer from near gridlock conditions. The Castleton Square area on the northeast part of town and the south corridor to Greenwood are frequently cited as the worst traffic areas in the city. As the new airport takes shape over the next several years, traffic will continue to worsen in that western corridor as well. While I-465 eventually will be expanded to 12 lanes in its total 55-mile loop, that will not be enough. The extension of I-69 south to Evansville will not relieve the pressure either because plans call for the extension to use the eastern leg of I-465 to go around the east side of Indianapolis where it will join I-69 south on the south side.

These discussions have turned their attention to the next stage in traffic control—mass transit. Already in operation on a small scale, the Clarion Health People Mover is a testing ground for an Automated Guideway Transit System, one of three possibilities. The People Mover runs between Methodist Hospital and the IUPUI Medical School. Although the distance is very short, it has proven to be a successful system, despite minor technical difficulties in the beginning of operation.

Currently there are three possibilities for mass transit in Indianapolis. The first is a Bus Rapid Transit System that would use existing traffic lanes to speed workers to and from the central city. The shortcoming of this system is that neither the interstates nor city streets have the lanes available to be designated solely for bus traffic. The second system is a Light Rail System that would use existing rail lines for a passenger system only, rather than freight. The shortcoming of this system is that extra rails would have to be added to existing lines. Though not technically difficult, this system would disrupt miles of businesses and homes that lie along existing rail lines. The third system is similar to the People Mover, but on a much larger scale. The People Mover is an elevated rail system that would have to be built over existing streets. While no system has been selected yet, six corridors have been identified that will utilize whatever system is chosen. All six would

begin downtown. They include a northeast corridor through Castleton to the town of Fishers, a northwest corridor to Zionsville, a west corridor to the new airport, an eastern corridor along Washington Street, a corridor south to Greenwood along U.S. 31 and Madison Avenue, and a southwest corridor to Plainfield.

In the last 30 years, Indianapolis has become a new city with a gleaming new downtown, a thriving sports industry with professional sports franchises, a nationally recognized cultural community, and a set of problems common to all large cities. Traffic congestion has become a problem in need of solution. As the national economy continues to move away from manufacturing and more toward a technology based economy, Indianapolis has been slower to adapt than other cities. But change is underway, as previously noted. Criticism has been leveled at the city because of its pace of change. Some of this criticism may be justified, while some of it is not justified because the pace of change is not as important as the fact that change is occurring. Indianapolis's problems are not as severe as other cities and this may explain, at least in part, the slower change of pace.

Throughout the history of Indianapolis, the city has grown from a dozen log cabins in the wilderness to the nation's 12th largest city. In nearly 200 years of existence, Indianapolis has had to change in order to survive. It has changed as evidenced by its growth, its acceptance of railroads, interurbans, industry, and an ever-changing cultural community. It has taken advantage of its location and its other strengths in order to grow, to market itself, and to prosper. In recent decades, the city has recognized the need to adapt again, in the face of a changing economy. It modified its governmental structure to better facilitate those changes. It took advantage of a diverse economy, thriving sports franchises, and a growing cultural community to face the future needs of its residents. The key for Indianapolis is that it has adapted in the past and it will adapt in the future. The pace is slower than other cities and slower than some may want, but that does not alter the fact that Indianapolis is changing as it has always changed and adapted in its own way to meet the future, just as its founders had intended.

A New City

BIBLIOGRAPHY

Books

Bakken, Darrell J. *Now That Time Has Had Its Say: A History of the Indianapolis Central Canal, 1835–2002*. Bloomington: First Books, 2003.

Barnhart, John D. and Riker, Dorothy L. *Indiana to 1816: The Colonial Period*. Indianapolis: The Indiana Historical Society and The Indiana Historical Bureau, 1970.

Bodenhamer, David J. and Barrows, Robert G., eds. *The Encyclopedia of Indianapolis*. Bloomington: Indiana University Press, 1994.

Buley, R. Carlyle. *The Old Northwest: Pioneer Period 1815–1840*. Vol. 1. Chicago: Lewis Publishing Company, 1931.

Burgess, Dale W. *Just Us Hoosiers and How We Got That Way*. Indianapolis: Unified College Press Inc., 1966.

Carmony, Donald F. *Indiana: A Self Appraisal*. Bloomington: Indiana University Press, 1966.

————. *Indiana 1816–1850: The Pioneer Era*. The Indiana Historical Society and The Indiana Historical Bureau, 1998.

Cathcart, Charlotte. *Indianapolis From Our Own Corner*. Indianapolis: The Indiana Historical Society, 1965.

Cottman, George S. and Hyman, Max R. *Centennial History and Handbook of Indiana*. Indianapolis: Max R. Hyman, Publisher, 1915.

Drago, Harry S. *Canal Days in America*. New York: Bramhall House, 1972.

Dunn, Jacob P. *Greater Indianapolis*. 2 vols. Chicago: Lewis Publishing Company, 1910.

Elsmore, Jane S. *Henry Ward Beecher: The Indiana Years, 1837–1847*. Indianapolis: The Indiana Historical Society, 1973.

Esarey, Logan. *History of Indiana, 1909*. Reprint. Indianapolis: Hoosier Heritage Press, Inc., 1970.

Fadely, James P. *Thomas Taggart: Public Servant, Political Boss, 1856–1929*. Indianapolis: The Indiana Historical Society, 1997.

Fatout, Paul. *Indiana Canals*. West Lafayette: Purdue University Press, 1972.

Geib, George and Geib, Miriam. *Indianapolis First*. Indianapolis: Indianapolis Chamber of Commerce, 1990.

Geib, George. *Indianapolis: Hoosier Circle City*. Tulsa: Continental Heritage Press, 1981.

Glabb, Charles N. and Brown, A. Theodore. *A History of Urban America*. 3rd rev. ed. New York: MacMillan Publishing Company, Inc., 1983.

Goldsmith, Stephen A. *The 21st Century City: Resurrecting Urban America.* Washington, D.C.: Regency Publishers, Inc. 1997.

Goodrich, DeWitt C. and Tuttle, Charles R. *An Illustrated History of the State of Indiana and A History of Each County Separately.* Indianapolis: Richard S. Peale and Company, Publishers, 1875.

Gray, Ralph, ed. *The Hoosier State: Readings in Indiana History.* 2 vols. Grand Rapids: William B. Eerdmans Publishing Company, 1980.

Gray, Ralph, ed. *Gentlemen From Indiana: National Party Candidates, 1836–1940.* Indianapolis: Indiana Historical Bureau, 1977.

Hale, Hester A. *Indianapolis: The First Hundred Years.* Indianapolis: Marion County Historical Society, 1987.

Harrison, Wyman. *Pages From the Geologic Past of Marion County.* Bloomington: Indiana Geological Survey, 1963.

Hamilton, Holman and Thornbrough, Gayle, eds. *Indianapolis in the Gay Nineties: The High School Diaries of Claude G. Bowers.* Indianapolis: The Indiana Historical Society, 1964.

Hendrickson, Walter B. *The Indiana Years: 1903–1941.* Indianapolis: Indiana Historical Society Publications, Vol. 26, No. 3, 1983.

Hodges, Laura F. *Early Indianapolis.* Indianapolis: C.E. Pavley and Company, 1918.

Holliday, John R. *Indianapolis and the Civil War.* Indianapolis: The Society of Indiana Pioneers, 1972.

Holloway, W.R. *Indianapolis: A Historical and Statistical Sketch of the Railroad City.* Indianapolis: Indianapolis Journal Print, 1870.

Horvath, Dennis E. and Horvath, Terri. *Cruise IN: A Guide to Indiana's Automotive Past and Present.* Indianapolis: Publishing Resources, 1997.

Hudnut, William H, III. *The Hudnut Years in Indianapolis, 1976–1991.* Bloomington: Indiana University Press, 1995.

————. *Cities on the Rebound: A Vision for Urban America.* Washington, D.C.: Urban Land Institute, 1998.

Hyman, Max, R., ed. *Hyman's Handbook of Indianapolis.* Indianapolis: Max R. Hyman Company, 1897.

Hyneman, Charles; Hofstetter, C. Richard; and O'Connor, Patrick F. *Voting in Indiana: A Century of Persistence and Change.* Bloomington: Indiana University Press, 1979.

Jackson, Marion T., ed. *The Natural Heritage of Indiana.* Bloomington: Indiana University Press, 1997.

Jarvis, Helen A., ed. *The City and the Bank, 1865–1965.* Indianapolis: Benham Press, 1965.

Johnson, Howard. *A Home in the Woods: Pioneer Life In Indiana.* Bloomington: Indiana University Press, 1978.

Kahn, E.J. Jr. *All in a Century: The First 100 Years of Eli Lilly and Company.* West Cornwall: Kahn, 1975.

Leary, Edward A. *Indianapolis: The Story of a City.* Indianapolis: The Bobbs Merrill Company, Inc., 1971.

————. *Indianapolis: A Pictorial History.* Virginia Beach: The Donning

Company, 1980.

Lindsey, Alton, ed. *Natural Features of Indiana*. Indianapolis: Indiana Academy of Science, 1966.

Madison, James H. *The Indiana Way: A State History*. Bloomington: Indiana University Press, 1986.

————. *Indiana Through Tradition and Change: A History of the Hoosier State and its People, 1920–1945*. Indianapolis: The Indiana Historical Society, 1982.

Marlette, Jerry. *Electric Railroads of Indiana*. Indianapolis: Hoosier Heritage Press, 1980.

Martin, John Bartlow. *Indiana: An Interpretation*. Bloomington: Indiana University Press, 1947.

McCullough, Robert G. *A Reanalysis of Ceramics From the Bowen Site: Implications For Defining the Oliver Phase of Central Indiana*. Muncie: Ball State University, 1991.

Nelson, Daniel. *Farm and Factory: Workers in the Midwest, 1880–1990*. Bloomington: Indiana University Press, 1995.

Nolan, Jeanette C. *Hoosier City: The Story of Indianapolis*. New York: Julian Messner, Inc., 1943.

Phillips, Clifton J. *Indiana in Transition: The Emergence of an Industrial Commonwealth, 1880–1920*. Indianapolis: The Indiana Historical Society and The Indiana Historical Bureau, 1968.

Roll, Charles. *Indiana: One Hundred and Fifty Years of American Development*. 5 vols. Chicago: Lewis Publishing Company, 1931.

Rose, Ernestine B. *The Circle: The Center of Our Universe*. Indianapolis: The Indiana Historical Society, 1957.

Sanford, Wayne. *The Civil War and Indianapolis*. Indianapolis: World War II Publications, Inc., 1992.

Schlereth, Thomas J. *US 40: A Roadscape of the American Experience*. Knoxville: University of Tennessee Press, 1985.

Sulgrove, Barry R. *History of Indianapolis and Marion County*. Evansville: Unigraphic Inc., 1884.

Taylor, Robert M. and McBirney, Connie A., eds. *Peopling Indiana: The Ethnic Experience*. Indianapolis: The Indiana Historical Society, 1996.

Taylor, Robert M.; Stevens, Errol Wayne; Ponder, Mary Ann; and Brockman, Paul, eds. *Indiana: A New Historical Guide*. Indianapolis: The Indiana Historical Society, 1989.

Teaford, Jon C. *Cities of the Heartland: The Rise and Fall of the Industrial Midwest*. Bloomington: Indiana University Press, 1993.

Thornbrough, Gayle, ed. *The Diary of Calvin Fletcher*. 9 vols. Indianapolis: The Indiana Historical Society, 1972–1983.

Thornbrough, Emma Lou. *Indiana in the Civil War Era, 1850–1880*. Indianapolis: The Indiana Historical Society and The Indiana Historical Bureau, 1965.

Weintraut, Linda and Nolan, Jane. *Pioneers in Banking: A History of Indiana National Bank*. Indianapolis: NBD Bank, 1997.

Welch, Robert. *The Blue Book of the John Birch Society*. Boston: West Islands

Publishing, 1961.

Wilson, William E. *Indiana: A History*. Bloomington: Indiana University Press, 1966.

Winslow, Hattie Lou and Moore, Joseph R.H. *Camp Morton 1861–1865: Indianapolis Prison Camp*. Indianapolis: The Indiana Historical Society, 1940.

Indiana Magazine of History articles

Abbot, Carl. "Indianapolis in the 1850s: Popular Economic Thought and Urban Growth." vol. 74 (December 1978): 293–315.

Barnhart, John D. "The Impact of the Civil War on Indiana." vol. 57 (September 1961): 185–224.

Blodgett, Geoffrey T., ed. "The Dawning World of Claude Bowers." vol. 61 (June 1965): 157–170.

Bogle, Victor. "Railroad Building in Indiana, 1850–1855." vol. 58 (September 1962): 211–232.

Braeman, John. "Albert J. Beveridge and the First National Child Labor Bill." vol. 60 (March 1964): 1–36.

————. "The Rise of Albert J. Beveridge to the United State Senate." vol. 53 (December 1957): 355–382.

Calhoun, Charles W. "Benjamin Harrison, Centennial President: A Review Essay." vol. 84 (June 1988): 135–160.

Giffin, William W. "The Political Realignment of Black Voters in Indianapolis, 1924." vol. 79 (June 1983): 133–166.

Griffin, Walter R. "Louis Ludlow and the War Referendum Crusade, 1935–1941." vol. 64 (December 1968): 262–288.

Kelley, Darwin, ed. "Lambdin P. Milligan's Appeal for State's Rights and Constitutional Liberty During the Civil War." vol. 66 (September 1970): 263–283.

Larson, John L., and Vanderstel, David G. "Agent of Empire: William Conner on the Indiana Frontier." vol. 80 (December 1984): 301–328.

Levine, Daniel. "The Social Philosophy of Albert J. Beveridge." vol. 58 (June 1962): 101–116.

Lindstrom, Richard. "It Would Break My Heart to See You Behind the Counter: Business and Reform at L.S. Ayres and Company in the Early Twentieth Century." vol. 93 (December 1997): 345–376.

Madison, James H. "Business and Politics in Indianapolis: the Branch Bank and the Junto, 1837-1846." vol. 71 (March 1975): 1–20.

Ramsey, Paul S. "The War Against German-American Culture: The Removal of German-American Language From the Indianapolis Schools." vol. 98 (December 2002): 285–304.

Sample, Bradford. "A Truly Midwestern City: Indianapolis on the Eve of the Great Depression." vol. 97 (June 2001): 129–147.

Sinkler, George. "Benjamin Harrison and the Matter of Race." vol. 65 (September 1969): 197–214.

Spotter, Allan. "Harrison and Blaine: Foreign Policy, 1889–1893." vol. 65 (September 1969): 215–228.

Westheimer, Lewis J. "The Indianapolis Treason Trials, the Election of 1864, and the Power of the Partisan Press." vol. 85 (September 1989): 236–260.

Williams, John A. "Stephen B. Elkins and the Benjamin Harrison Campaign and Cabinet, 1887–1891." vol. 68 (March 1972): 1–23.

Magazines

Indianapolis Monthly: City Guide, Emmis Publishing LP, 2003.

Jackson, Dale. "Indianapolis: A Born Again Hoosier Diamond in the Rust." *Smithsonian*, July 1987, pp. 70–79.

Levathes, Louise E. "Indianapolis: City on the Rebound." *National Geographic*, August 1987, pp. 1–30.

This is Indianapolis. Indianapolis Convention and Visitors Association, 2003.

INDEX